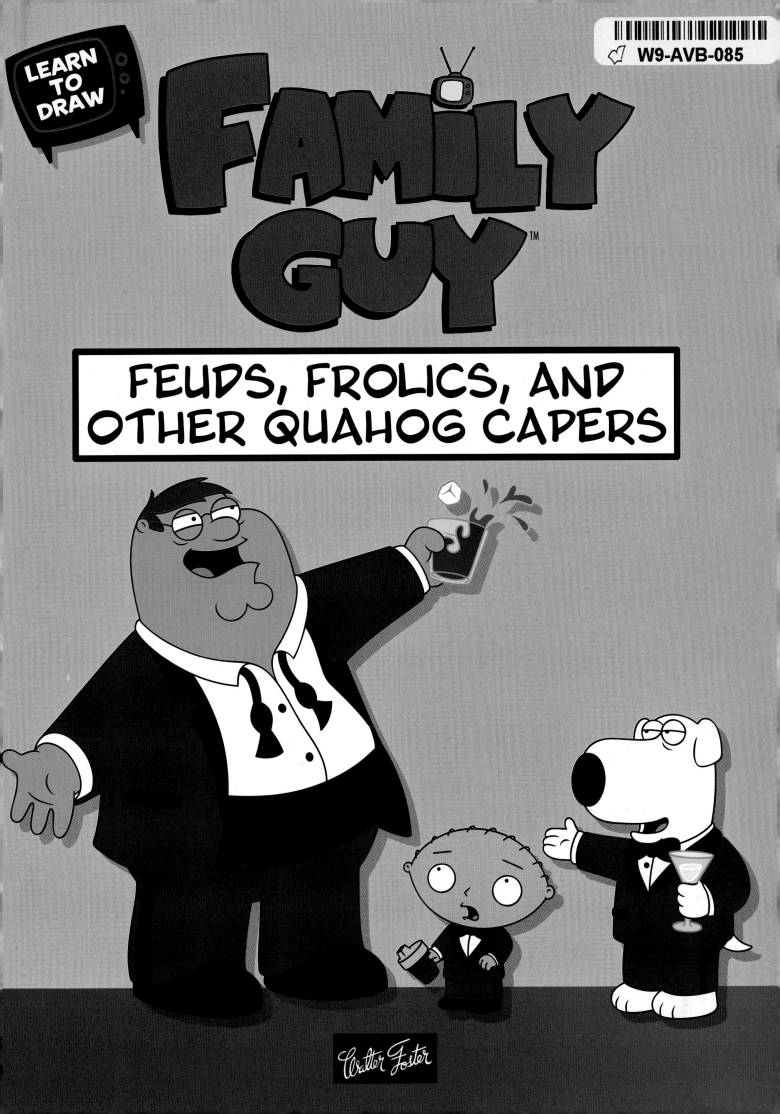

LEARN TO DRAW

FAMILY GUY™

FEUDS, FROLICS, AND OTHER QUAHOG CAPERS

Walter Foster

Text on pages 26, 48, 98, and 108 written by Jennifer Gaudet
Step-by-step illustrations by Kristina Marroquin-Burr

www.walterfoster.com
6 Orchard Road, Suite 100
Lake Forest, CA 92630

Printed in China
1 3 5 7 9 10 8 6 4 2

# TABLE OF CONTENTS

# HOW TO USE THIS BOOK

IN THIS BOOK YOU'LL LEARN HOW TO DRAW THE GRIFFIN FAMILY AND YOUR FAVORITE QUAHOGIANS IN A VARIETY OF POSES AND GETTING INTO ALL KINDS OF MISCELLANEOUS MISCHIEF. WITHIN EACH SECTION, YOU'LL FIND STEP-BY-STEP INSTRUCTIONS THAT ARE EASY TO FOLLOW, NO MATTER YOUR ARTISTIC SKILL LEVEL. EACH DRAWING BEGINS WITH A BASIC SHAPE, AND EACH STEP BUILDS ON THE PREVIOUS, AS SHOWN BELOW.

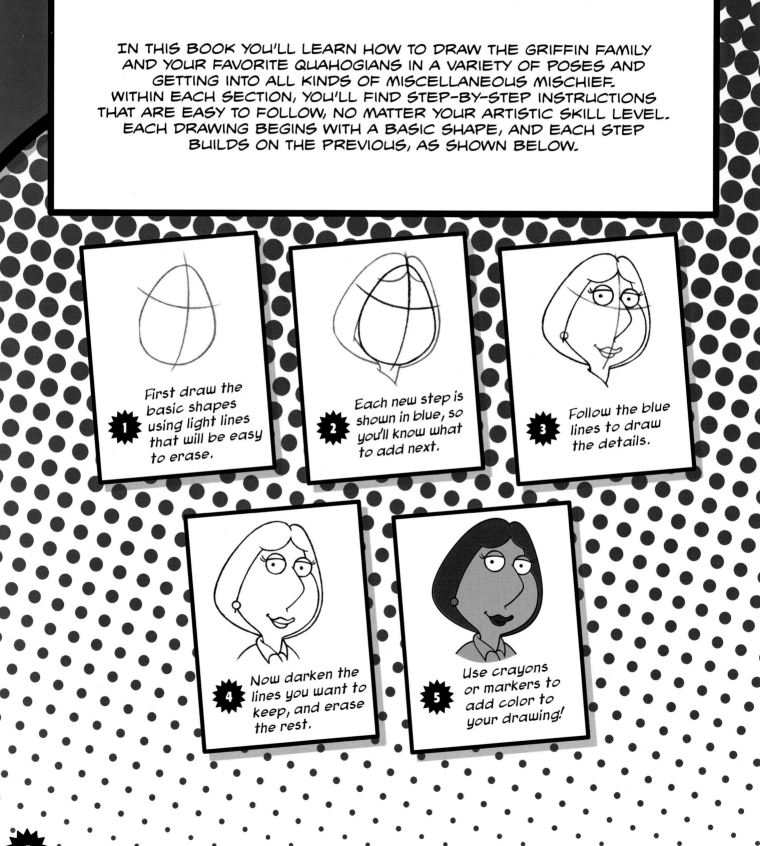

**1** First draw the basic shapes using light lines that will be easy to erase.

**2** Each new step is shown in blue, so you'll know what to add next.

**3** Follow the blue lines to draw the details.

**4** Now darken the lines you want to keep, and erase the rest.

**5** Use crayons or markers to add color to your drawing!

# MEET THE GRIFFINS

## WELCOME TO THE WORLD OF THE GRIFFINS,

A FAMILY WHO CAN'T HELP GETTING INTO A NEVER-ENDING SERIES OF CRAZY ADVENTURES, RANGING FROM TRAVELING IN TIME TO BEING SENT TO PRISON. WHETHER YOU THINK YOU KNOW EVERYTHING THERE IS TO KNOW ABOUT THE GRIFFINS OR IF YOU'RE NEW TO TELEVISION'S MOST ANARCHIC ANIMATED COMEDY, THIS BOOK IS FULL OF CREATIVE FUN ABOUT THE MOST INSANE FAMILY ON TV.

IF YOU'RE READY FOR JOKES ABOUT POP CULTURE, SILLY SHENANIGANS, AND GENERAL NUTTINESS, TURN THE PAGE AND SAY HELLO TO PETER, LOIS, MEG, CHRIS, STEWIE, BRIAN, AND THEIR FRIENDS!

# WELCOME TO QUAHOG— AND BEYOND!

WHEREVER THE GRIFFINS FIND THEMSELVES, YOU CAN BE SURE THAT UNUSUAL THINGS ARE BOUND TO HAPPEN. AND THEY DO, WHETHER THEY'RE AT HOME IN QUAHOG, DEALING WITH PESKY FEUDS AND BREAKING INTO SONG AT THE MOST INAPPROPRIATE OF MOMENTS, OR WHEN THEY'RE AWAY ON A FAMILY VACATION TO LAS VEGAS OR ON ONE OF STEWIE AND BRIAN'S INFAMOUS ROAD TRIPS, WHICH ULTIMATELY LEAD THEM ACROSS EUROPE.

THE WORLD OF *FAMILY GUY* IS FAR FROM NORMAL, AND THE GRIFFINS ARE PRETTY MUCH THE EXACT OPPOSITE OF YOUR NORMAL FAMILY: FATHER PETER IS OFFICIALLY RETARDED, LOIS IS A REFORMED KLEPTOMANIAC, DAUGHTER MEG IS THE CONSTANT BUTT OF EVERY FAMILY JOKE, SON CHRIS ONCE HAD A MONKEY LIVING IN HIS CLOSET, AND BABY STEWIE INVENTED HIS OWN TIME MACHINE. AS IF ALL THAT WEREN'T ENOUGH, THEY HAVE A TALKING WHITE LABRADOR NAMED BRIAN! QUAHOG IS ONE CRAZY PLACE TO BE.

THIS BOOK FOLLOWS THE GRIFFINS ON ADVENTURES AND ESCAPADES NEAR AND FAR, INCLUDING FEUDS, FOIBLES, FROLICS, VARIOUS CAPERS, AND GENERAL MAYHEM. YOU'LL DRAW, SKETCH, AND GET YOUR CREATIVE JUICES FLOWING AS YOU MAKE YOUR WAY THROUGH SOME OF THE MOST MEMORABLE MOMENTS AND SPECIAL THEMES FEATURED ON THE SHOW OVER THE YEARS. THERE'S SOME FAN TRIVIA AND CHARACTER FACTS SPRINKLED IN TOO. THE MADNESS BEGINS WITH THE QUIZ ON THE NEXT PAGE...GET READY TO GET UP CLOSE AND PERSONAL WITH THE GRIFFIN CLAN!

**1** It's movie night! What's your pick?
   a. Something artsy and European. Black and white, with subtitles if possible.
   b. Near-future dystopian sci-fi. Or a British historical drama. Whatevs.
   c. A 1980s classic. Preferably set in high school.
   d. Teen rom-com.
   e. A Hollywood epic. Something weepy.
   f. Porn.

**2** Uh-oh. The electricity's out—but there are candles. Which book?
   a. Something weighty and profound. An examination of what it means to be alive.
   b. Something with colorful, tactile pictures of cows and sheep and ducks. Or Machiavelli's *The Prince*.
   c. Comics all the way! Or I'd tell a story.
   d. A teen magazine. Something that plays on your insecurities.
   e. The latest bestselling bodice-ripper.
   f. Porn.

**3** On your birthday:
   a. Drinks and music are in order—at a seriously classy establishment.
   b. There had BETTER be a party. And presents. Or else.
   c. It's decided: Beers with the guys.
   d. A party, attractive people, and Seven Minutes in Heaven. What could possibly go wrong?
   e. No fuss, please. Age is just a number.
   f. I'll be in my room.

**4** What music are you into?
   a. The Rat Pack
   b. Musicals
   c. 1980s
   d. Pop (the latest boy band)
   e. I used to be in a folk duo
   f. Rock

**5** Everyone should have a hobby. What's yours?
   a. Working on that novel...
   b. I'm a master of invention.
   c. TV. Beer.
   d. Journaling. Obsessing.
   e. Playing the piano. I just don't have the time these days.
   f. Drawing.

**6** At the tattoo shop, you...
   a. Already have a tattoo. No need for more.
   b. A tattoo?! No freakin' way!
   c. Get something large, very visible, and ultimately regrettable. You were drunk.
   d. Choose a butterfly. It's what everyone else is getting.
   e. Have "serenity" inked on your lower back.
   f. A tattoo? That would tickle!

**7** What's your drink of choice?
   a. Martini
   b. Milk
   c. Beer
   d. Diet soda
   e. Wine
   f. Regular soda

**8** Animals are cool. If you could be one, what would you want to be?
   a. A dog. Every time.
   b. Something cute. Or sexy.
   c. A lion, or a whale, or a peterodactyl...
   d. A donkey.
   e. A fox.
   f. A monkey! But not an evil one...

CURIOUS ABOUT YOUR RESULTS?
CHECK YOUR ANSWERS ON THE LAST PAGE!

# SUPERHERO GRIFFINS

## SUPER GRIFFINS TO THE RESCUE! (OR TO THE BATHROOM.)

THE SAVIORS OF QUAHOG, ALSO REFERRED TO AS QUAHOG'S NOT-SO-FINEST, MAY NOT EMBODY WHAT YOU'D EXPECT FROM TYPICAL SUPERHEROES, BUT YOU CAN BE SURE THAT IN THEIR OWN "SUPER DOUCHY" WAY, SUPER FART, PUNCH-DRUNK POOCH, AND DIAPER DUDE WILL SAVE THE DAY. WHEN DASTARDLY THINGS ARE AFOOT IN QUAHOG AND THE EVIL TELEKINETIC TERROR IS PLOTTING UNSPEAKABLE ATROCITIES, ONLY THE SUPER GRIFFINS CAN SAVE QUAHOG FROM THE WRATH OF HIS JET PACK-FUELED RAGE. WITH THE AROMATIC ABILITY OF SUPER FART, THE INSATIABLE THIRST OF PUNCH-DRUNK POOCH, AND THE TRUSTY DIAPER DUDE WHO LEAVES NO SUPER POOP BEHIND, QUAHOG IS IN PRETTY AWESOME HANDS. JOIN THE SUPER GRIFFINS AND THEIR HEROIC TALENTS WITH THESE ULTRA SUPER-POWERED DRAWING LESSONS.

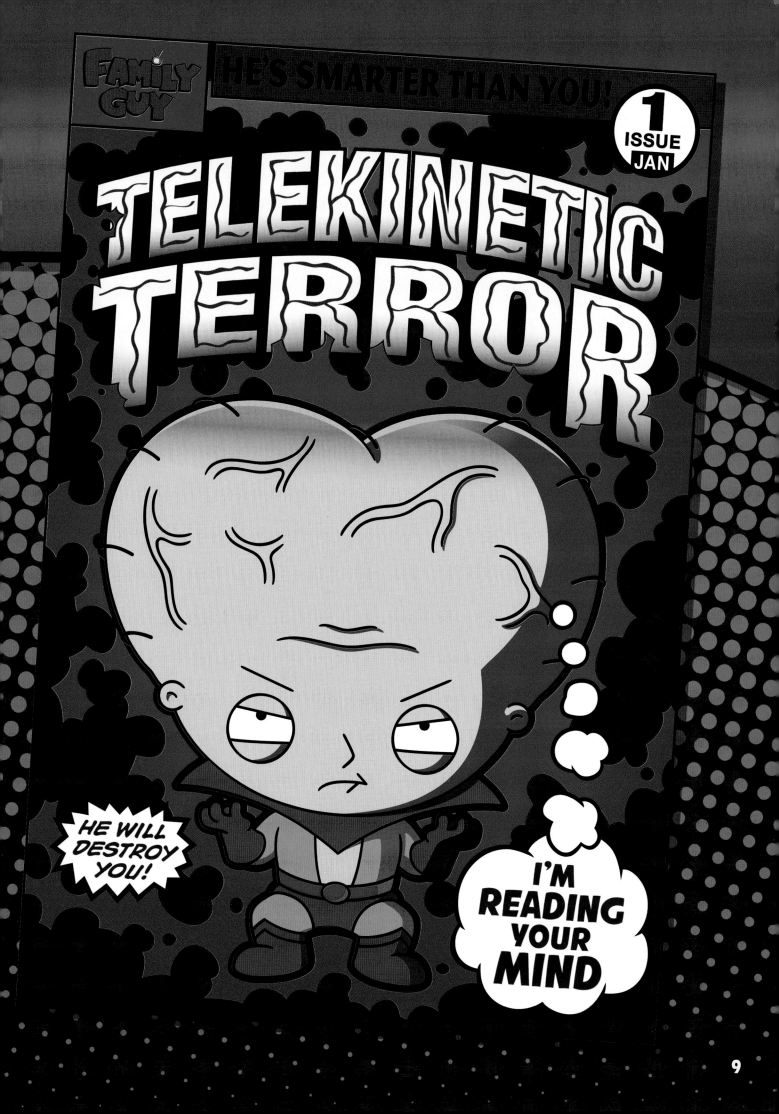

# PETER

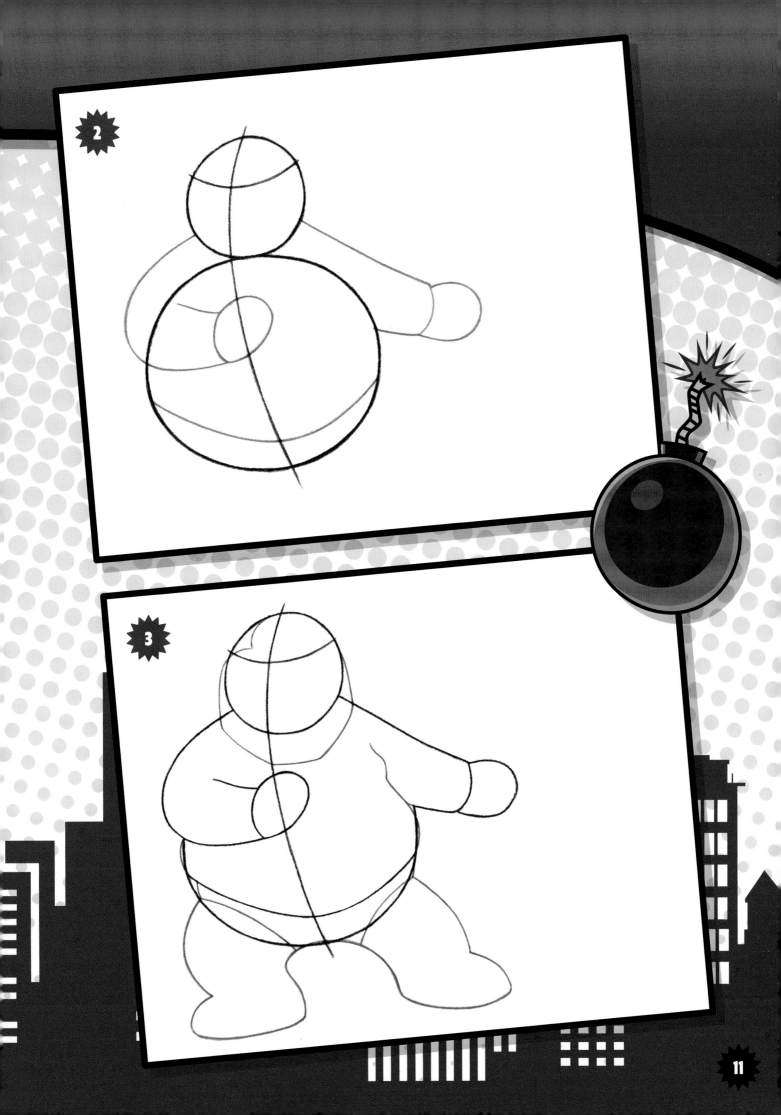

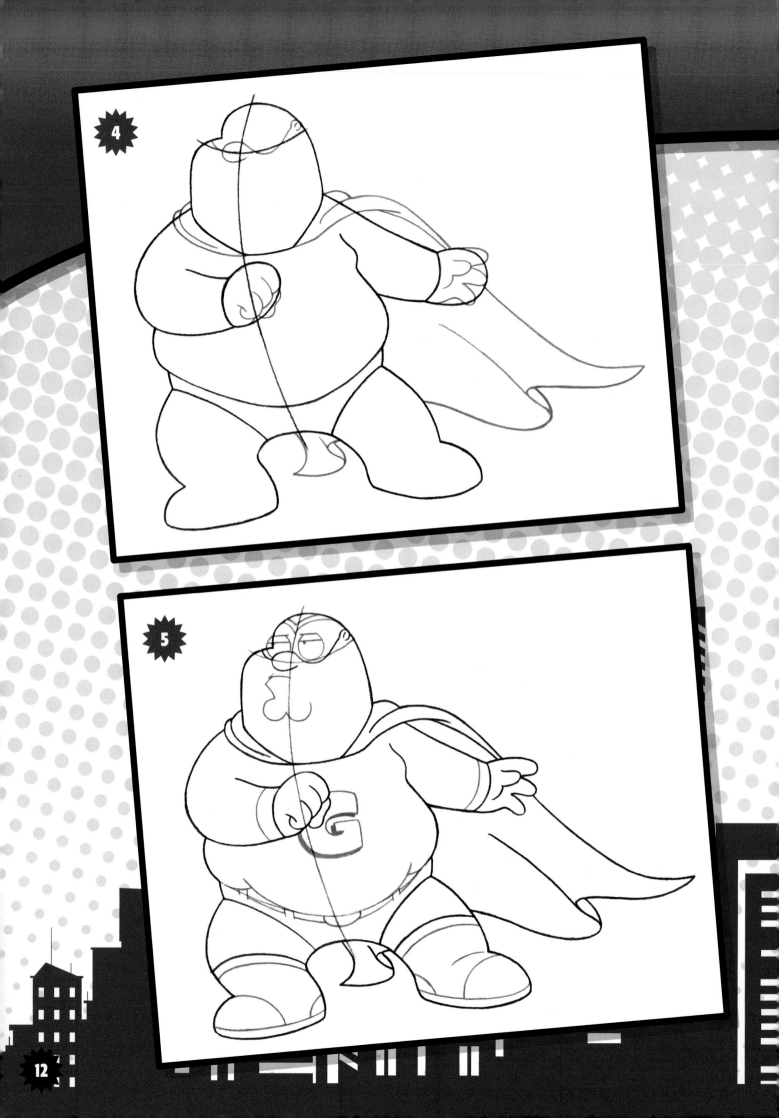

4

5

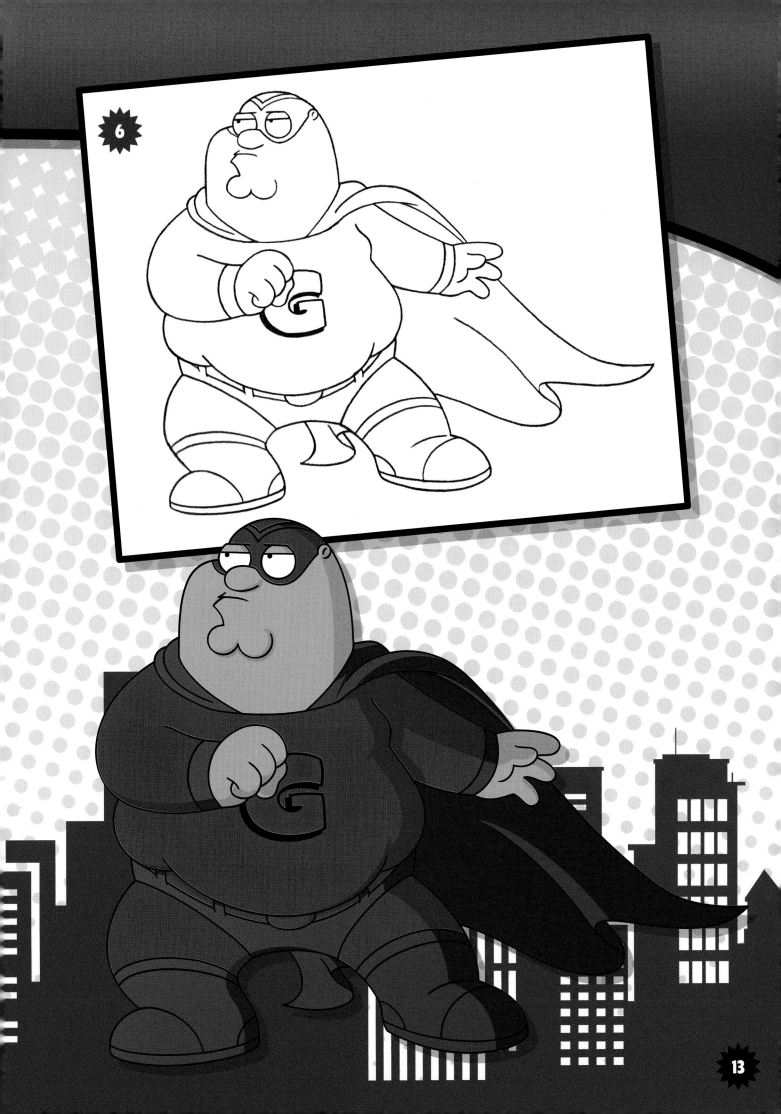

6

# STEWIE

**1**

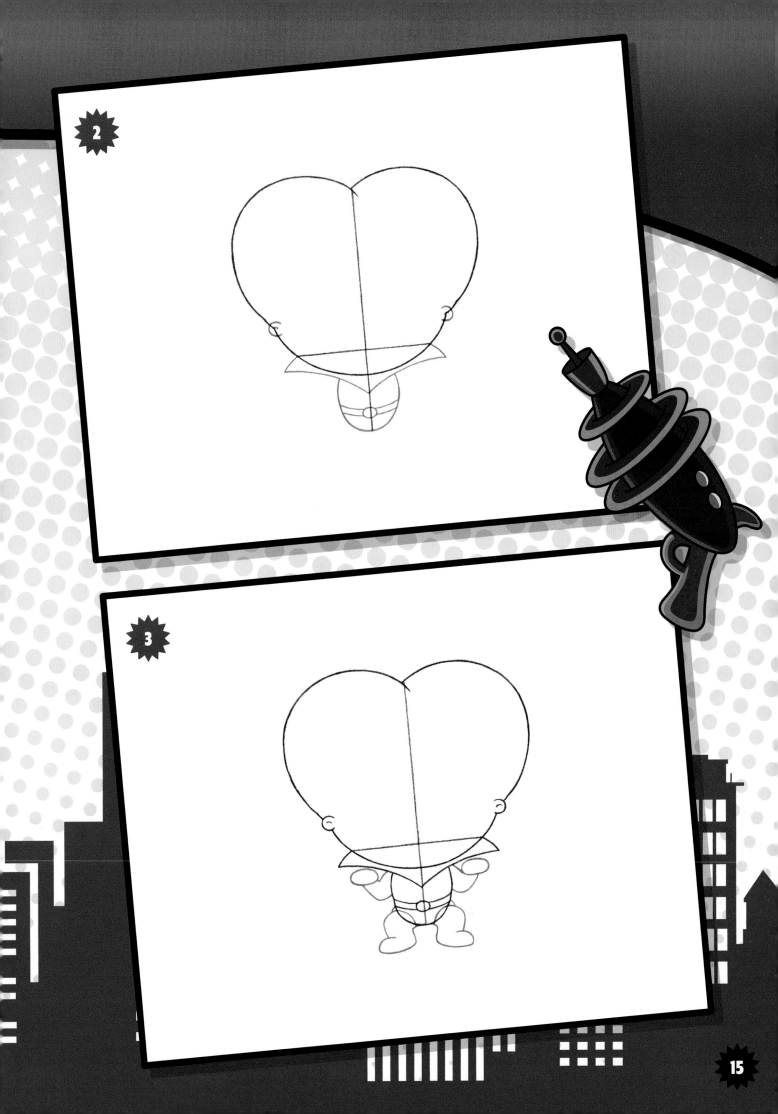

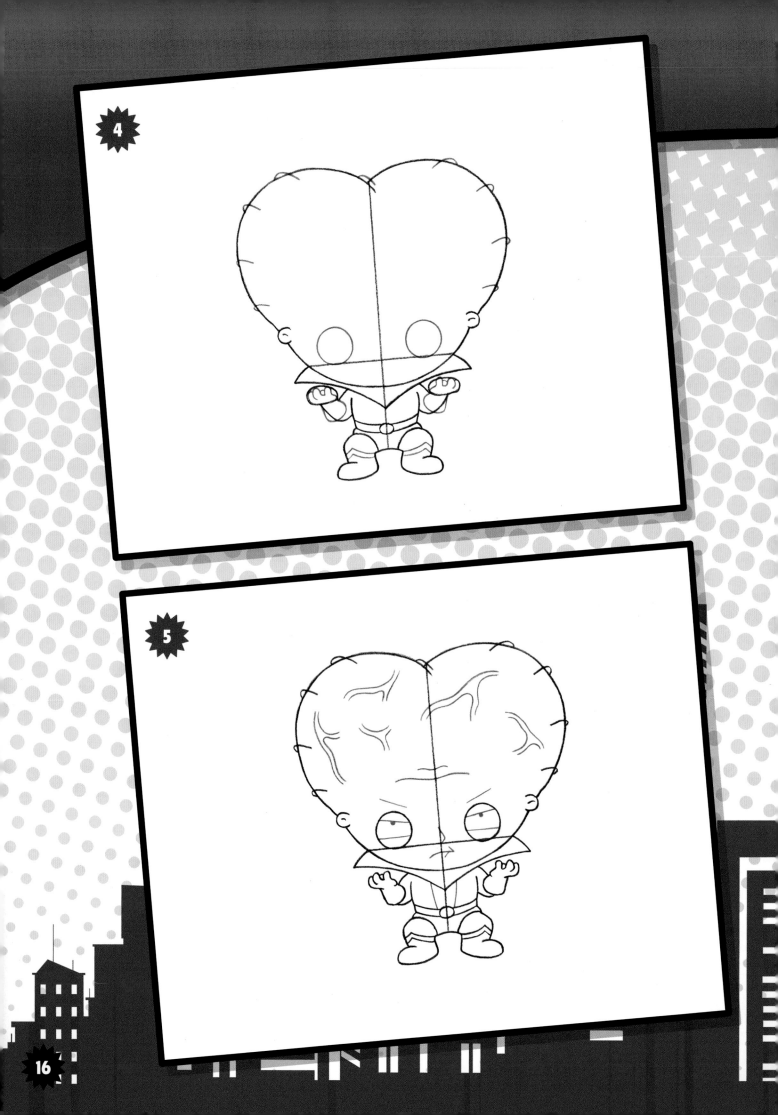

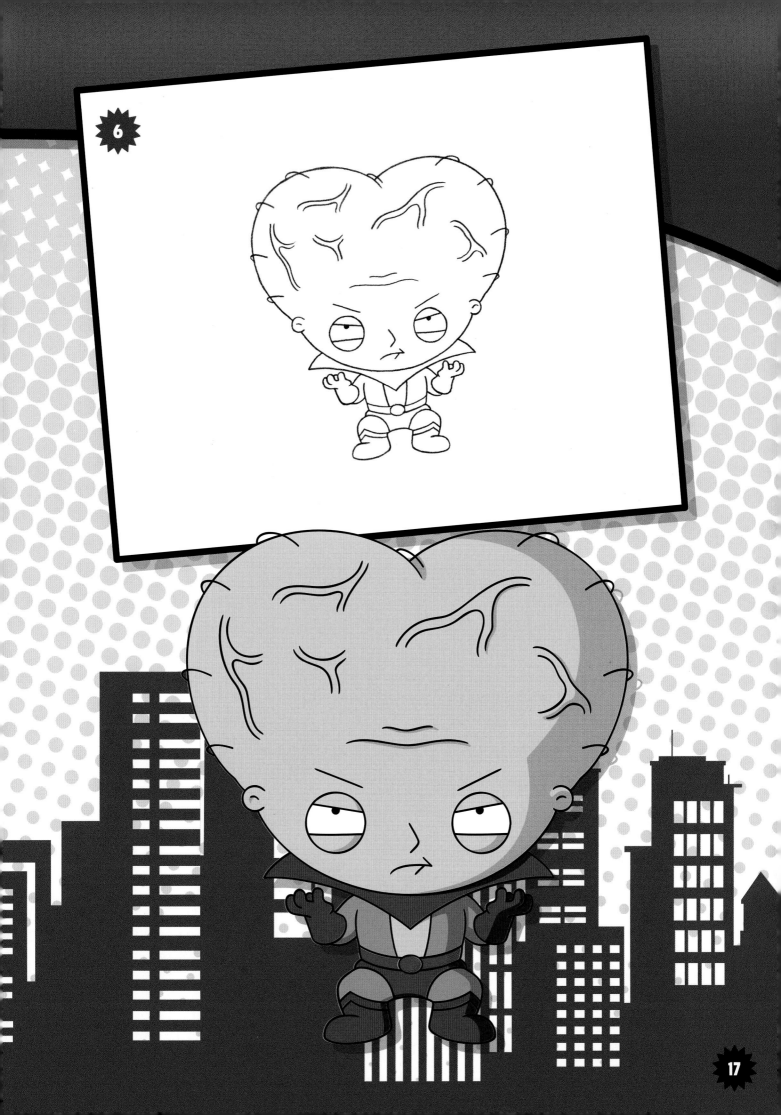

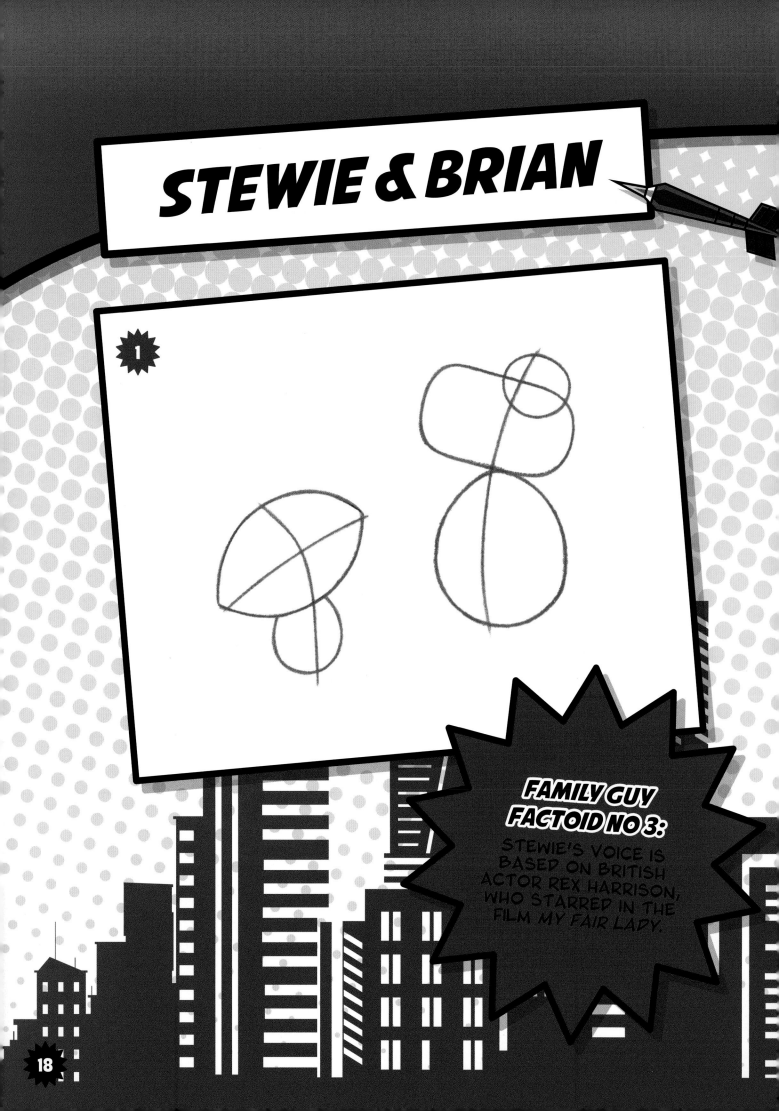

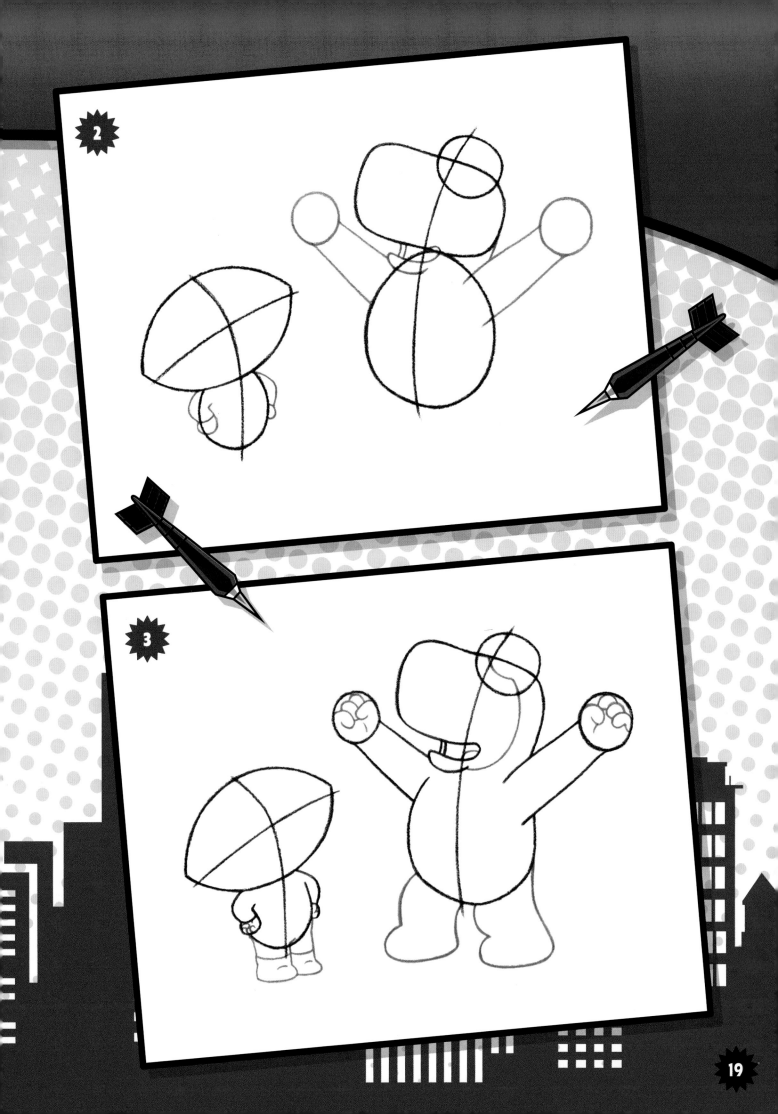

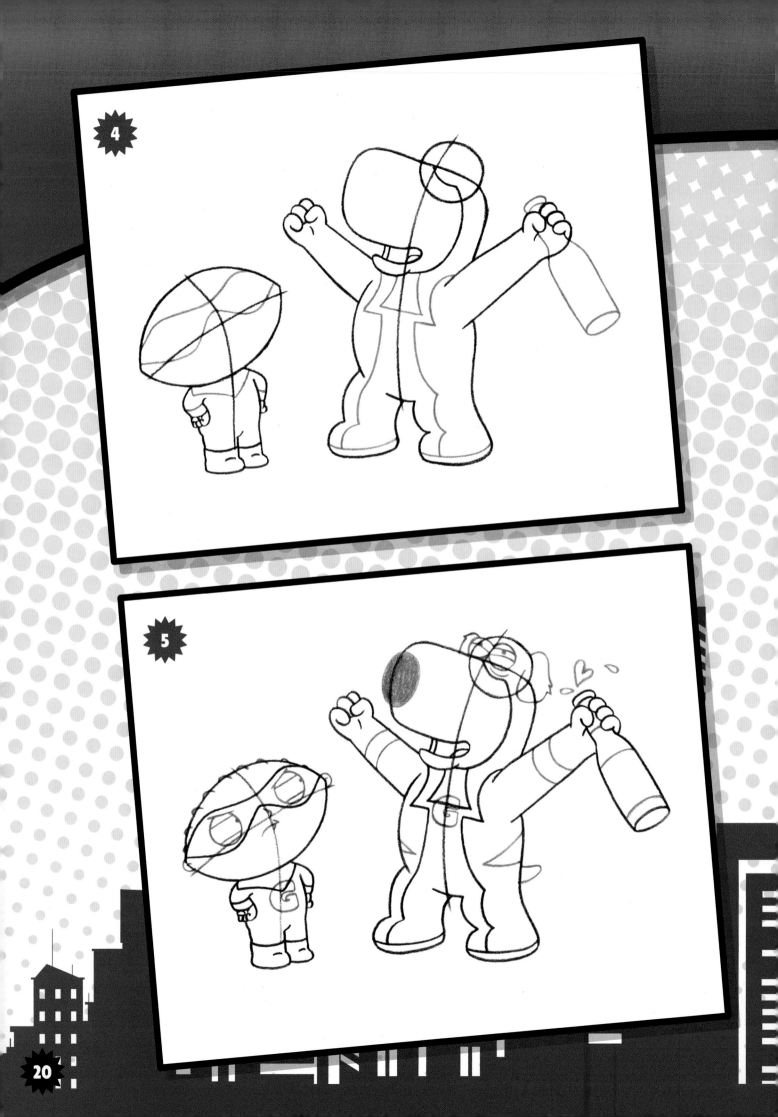

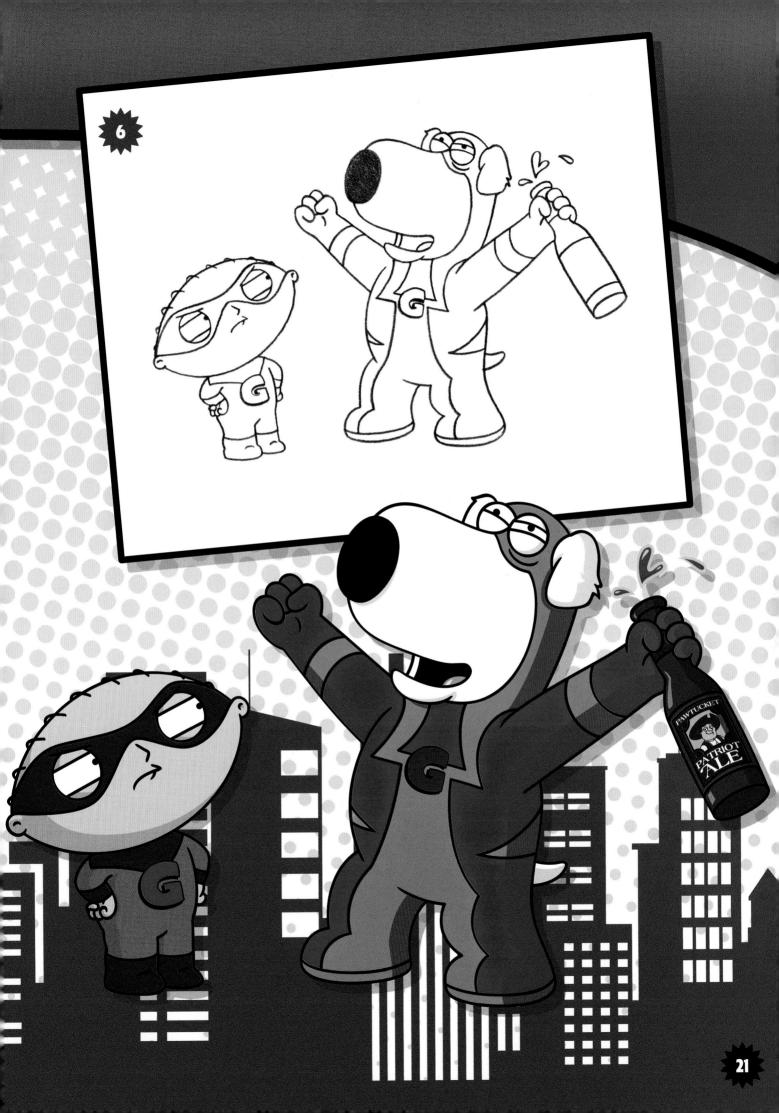

# BRIAN, PETER & STEWIE

**FAMILY GUY FACTOID NO 4:**

PETER IS KNOWN FOR BEING IMPULSIVE AND JEALOUS—HE ONCE PUNCHED A WHALE AT SEA WORLD THAT KISSED LOIS.

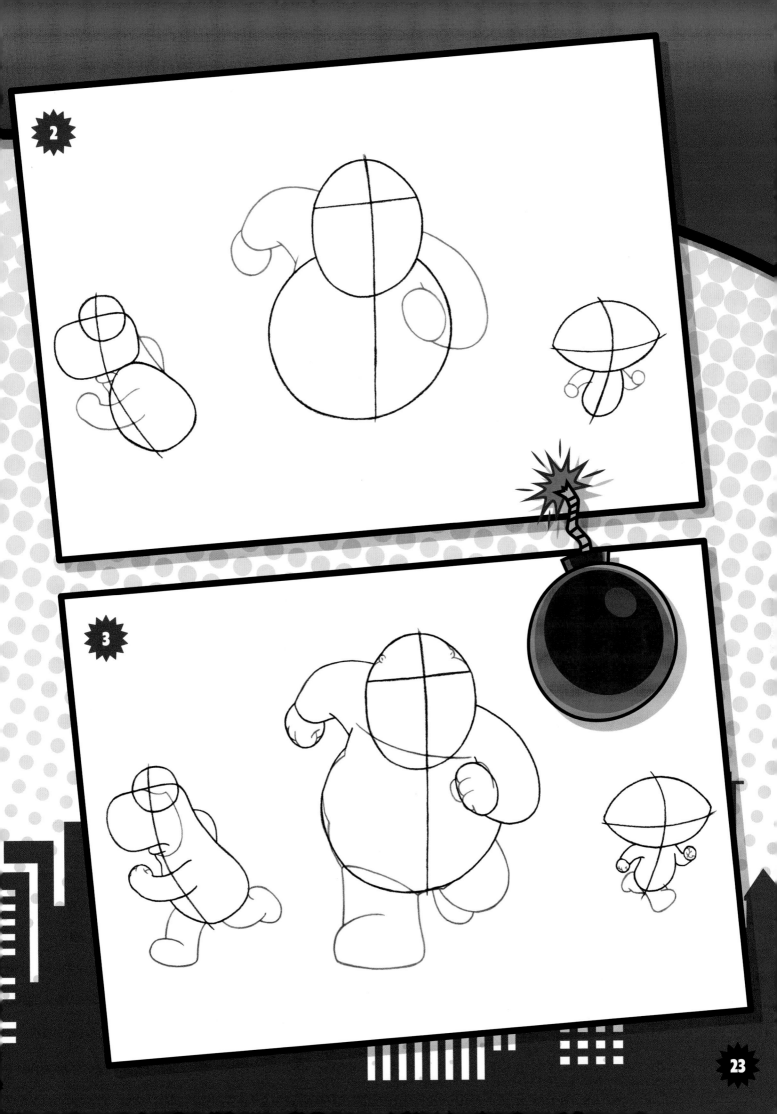

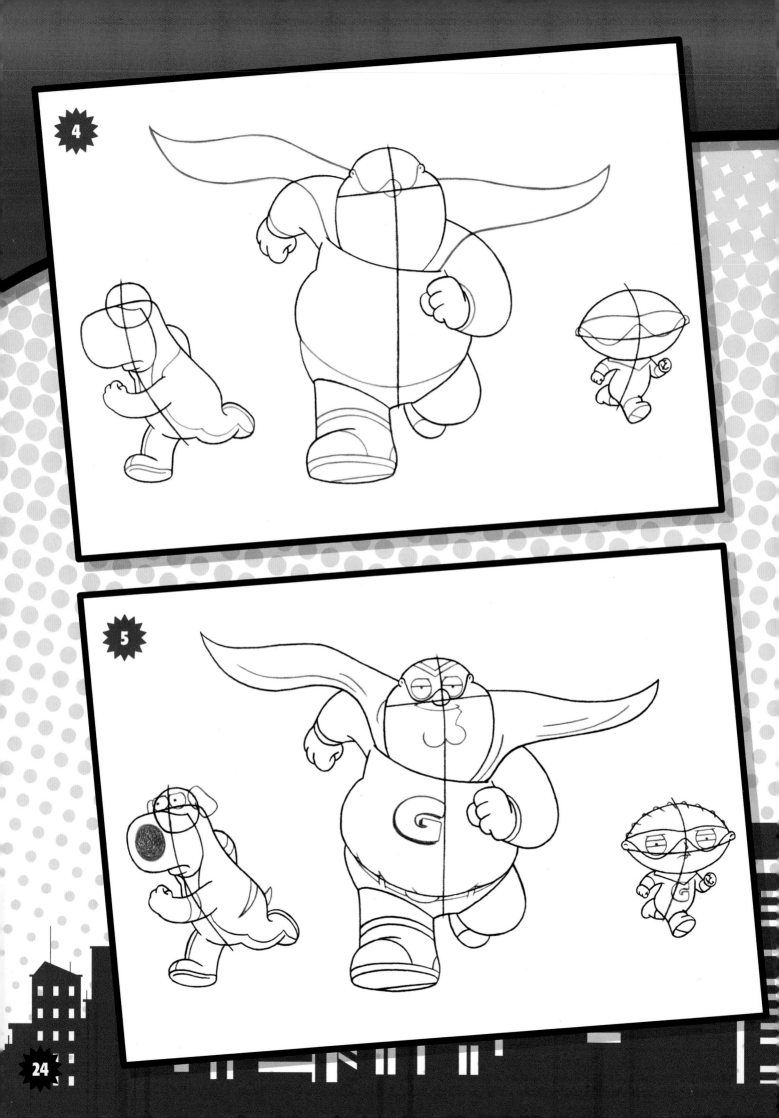

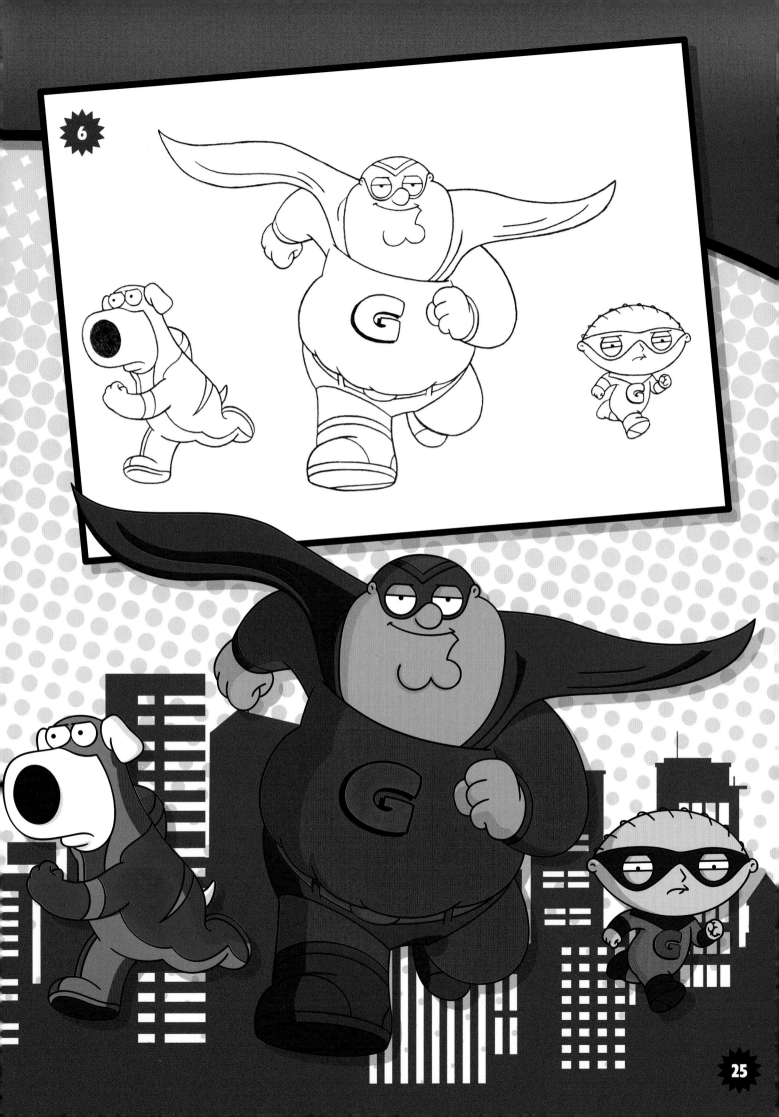

6

# MUSICAL MANIA

WHETHER PERFORMING ORIGINAL TRACKS SUCH AS "G-CHORD" OR SINGING ALONG WITH CLASSIC DITTIES LIKE "SHIPOOPI," STEWIE IS NO STRANGER TO ELABORATE MUSICAL NUMBERS. THIS SECTION IS A MELODIC TRIBUTE TO THE ICONIC MUSICAL ERAS AND AMAZING STYLES STEWIE HAS MODELED AND IMPERSONATED. TAKE A JOURNEY BACK IN TIME WITH THE BABY OF THE GRIFFIN HOUSEHOLD, AND WITNESS HIM DRESSED AS A HIPPIE OF THE 1960S, DOING AN ELVIS IMPERSONATION, WEARING A 1980S PRINCE GET-UP, PERFORMING A GRUNGY NIRVANA COVER, AND DONNING BOW TIES AND SUSPENDERS WITH RUPERT ALL THE WAY BACK FROM THE TURN OF THE CENTURY.

THAT IS MY JAM!

groovy!

Hey, DADDY-O!
Saturday Night Only!
At the Quahog Memorial Auditorium
LIVE PERFORMANCE

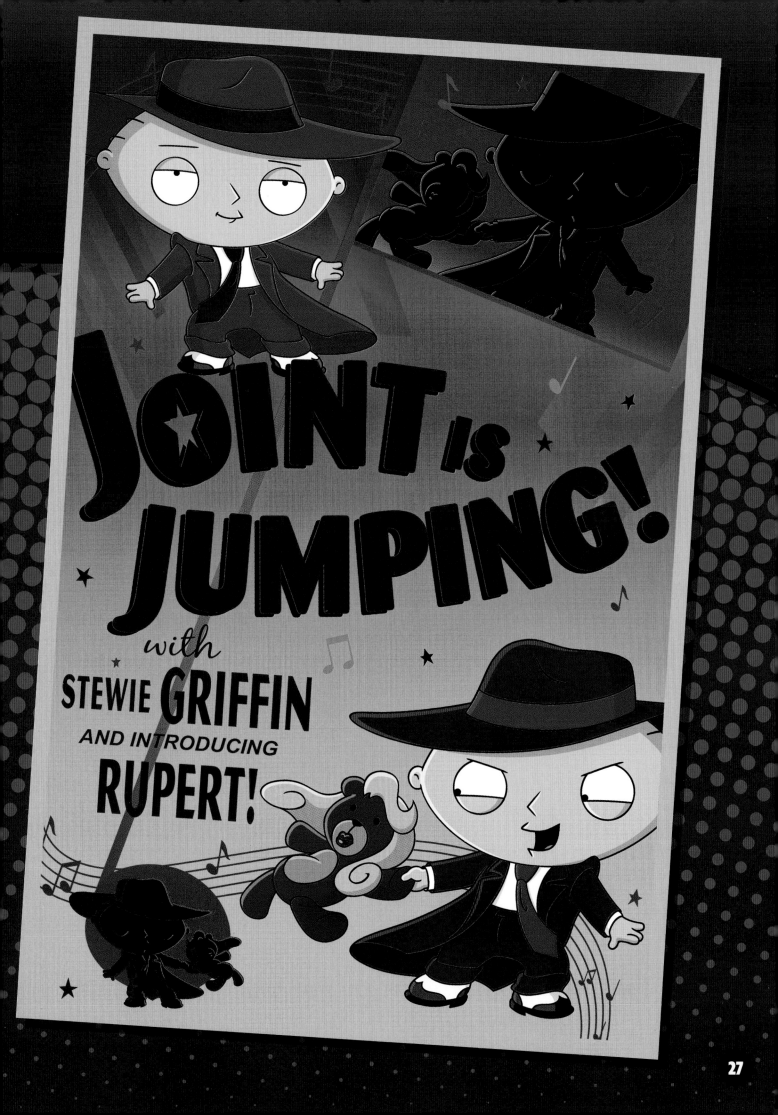

# 1900s

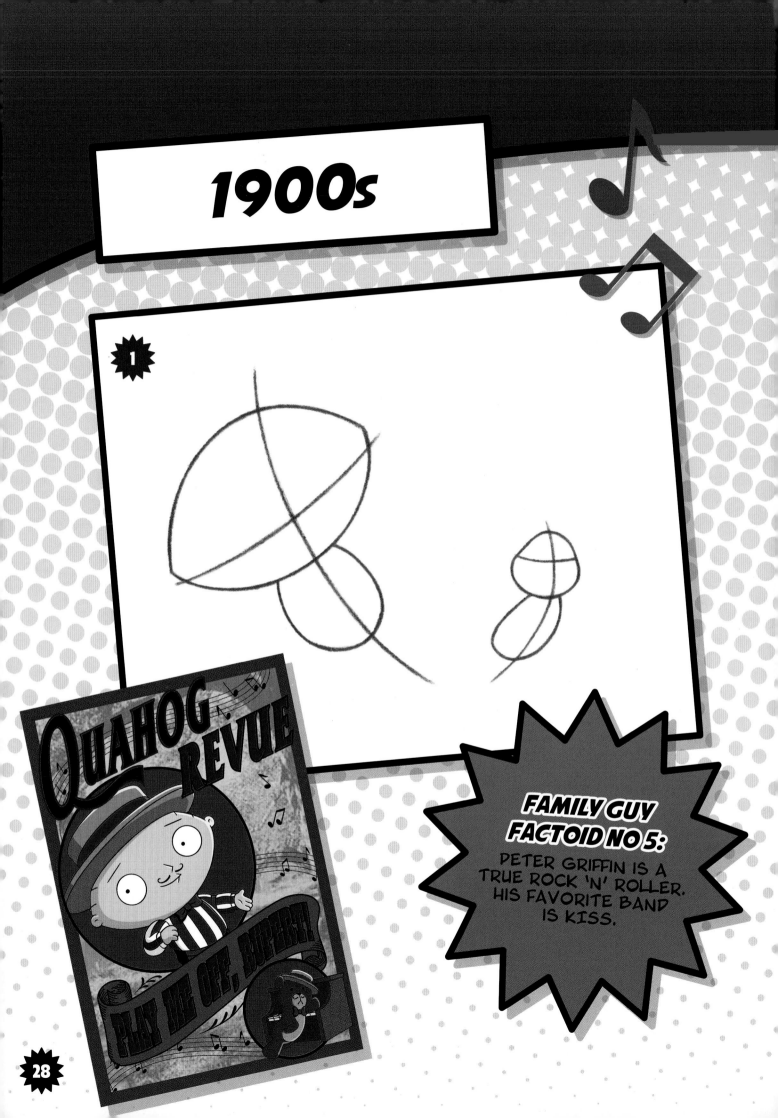

**FAMILY GUY FACTOID NO 5:**
PETER GRIFFIN IS A TRUE ROCK 'N' ROLLER. HIS FAVORITE BAND IS KISS.

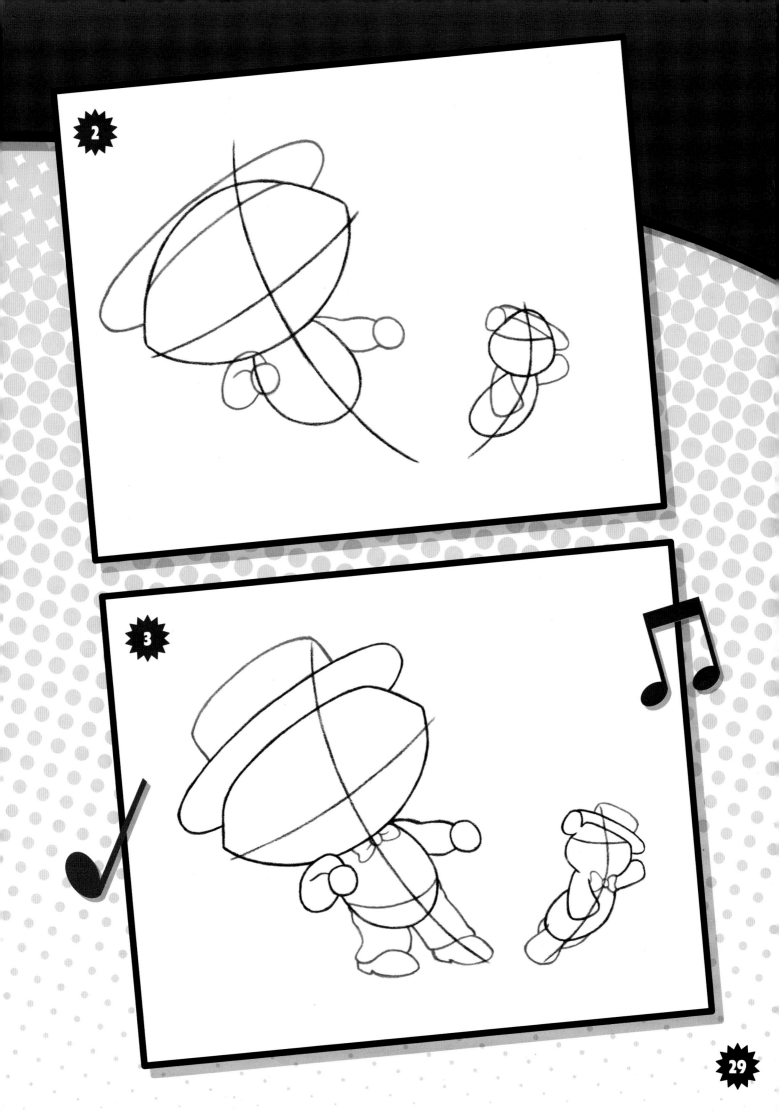

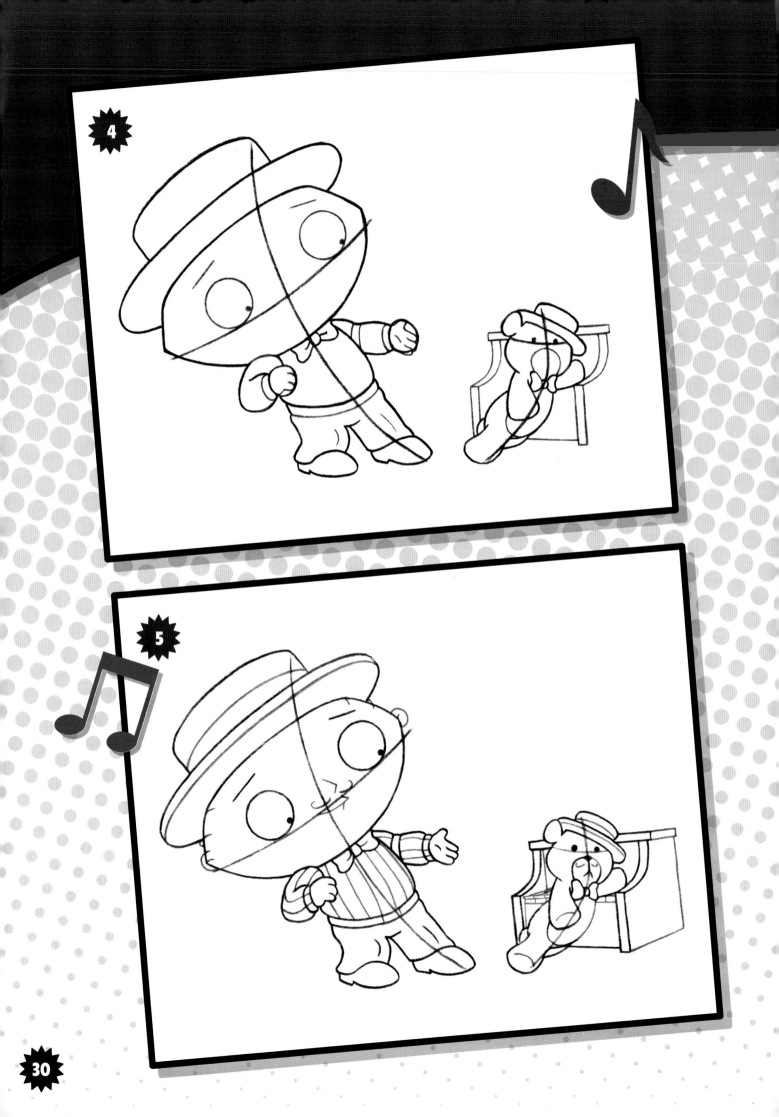

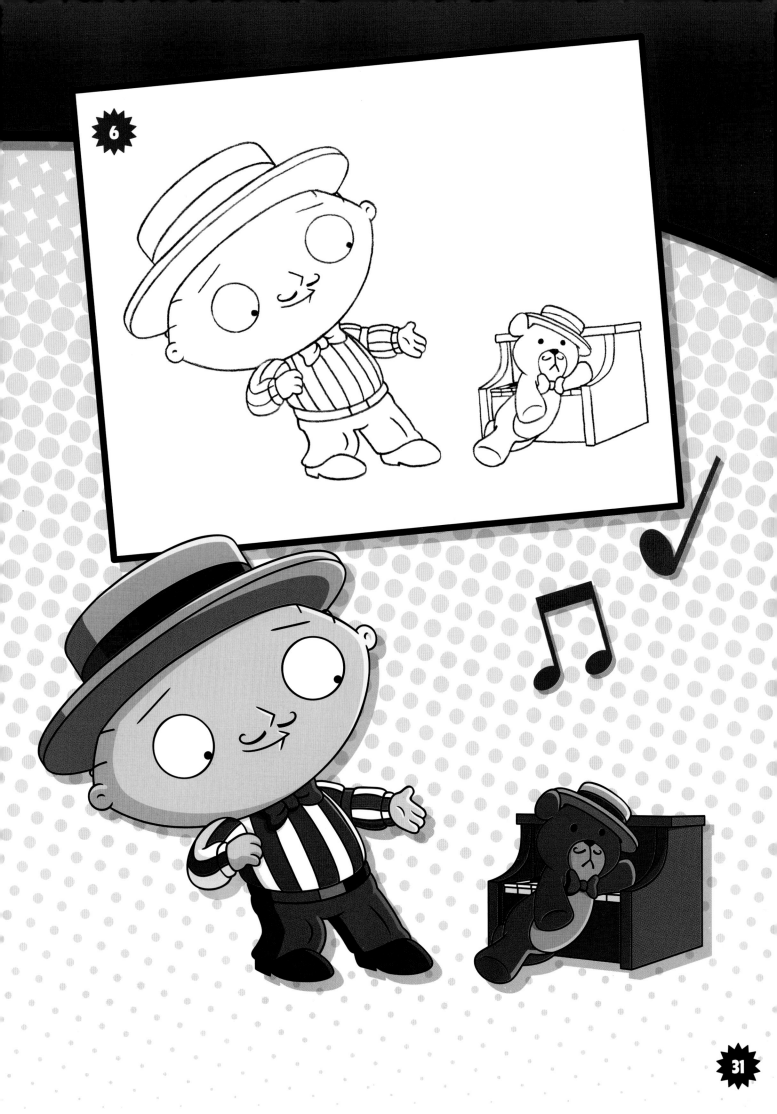

# 1950s

**1**

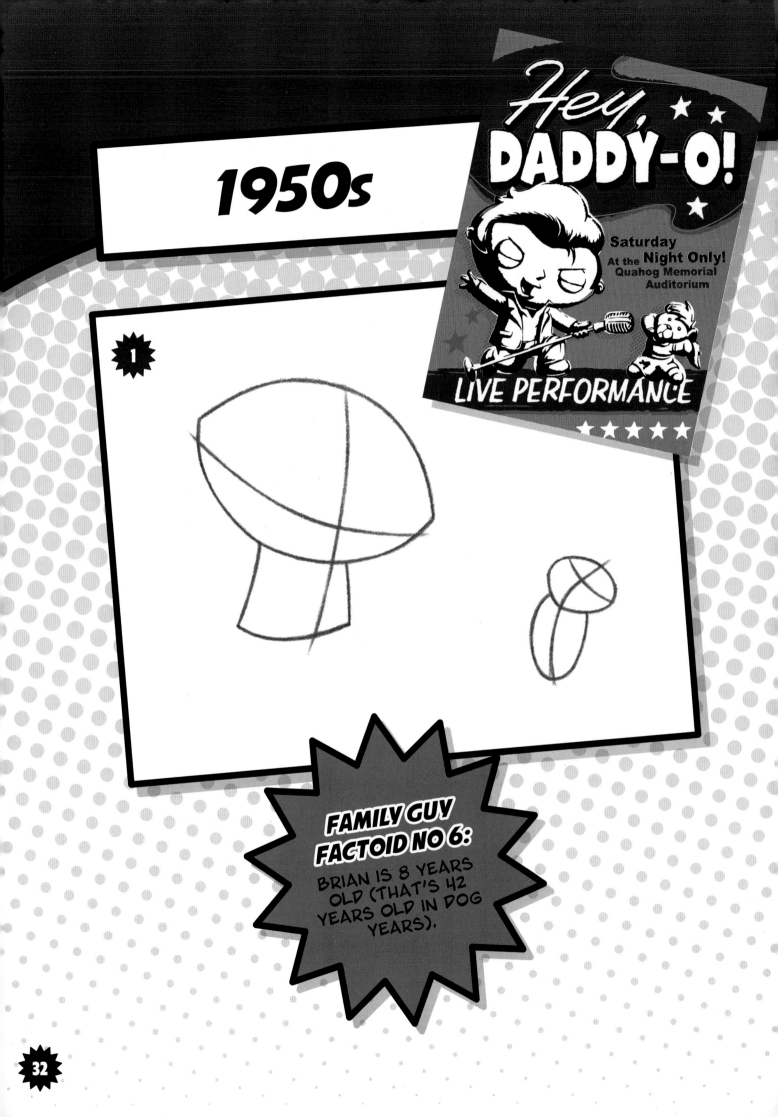

**FAMILY GUY FACTOID NO 6:**

BRIAN IS 8 YEARS OLD (THAT'S 42 YEARS OLD IN DOG YEARS).

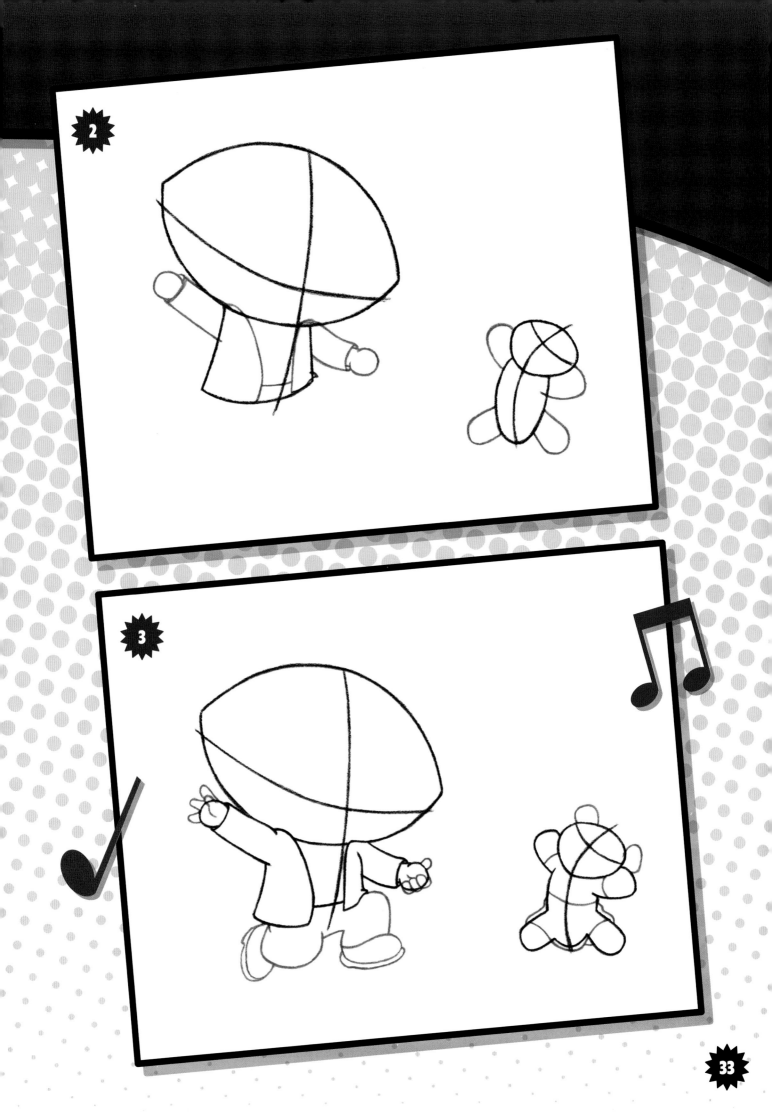

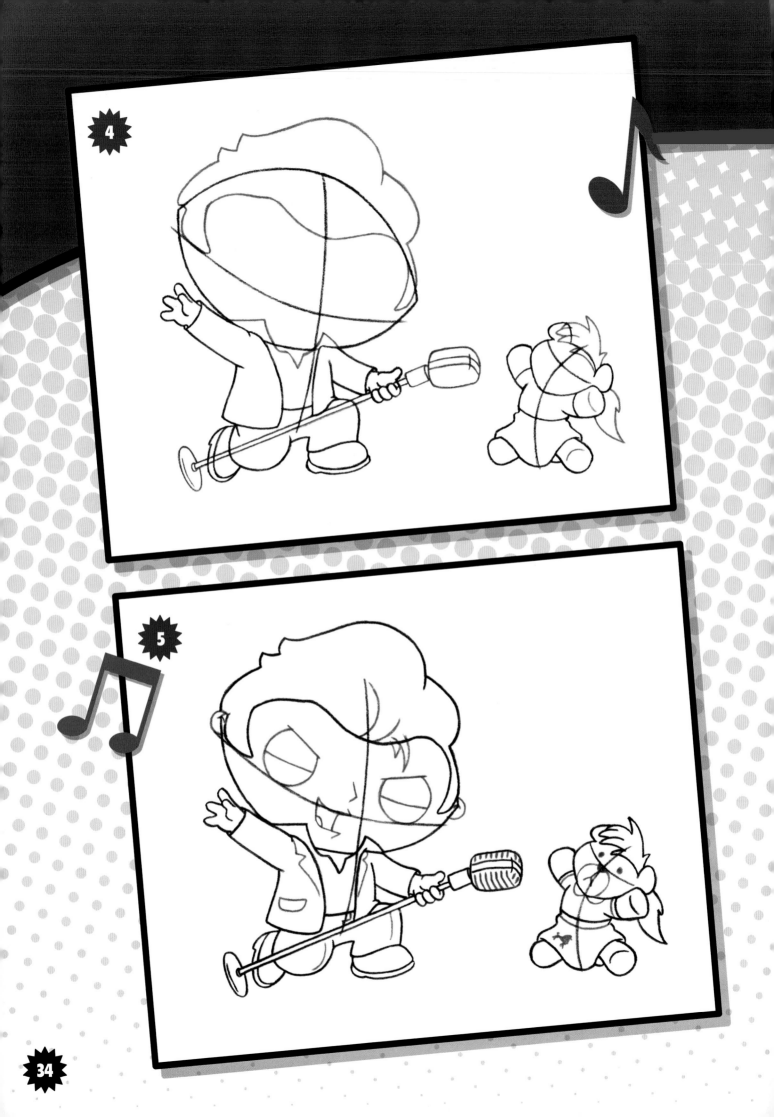

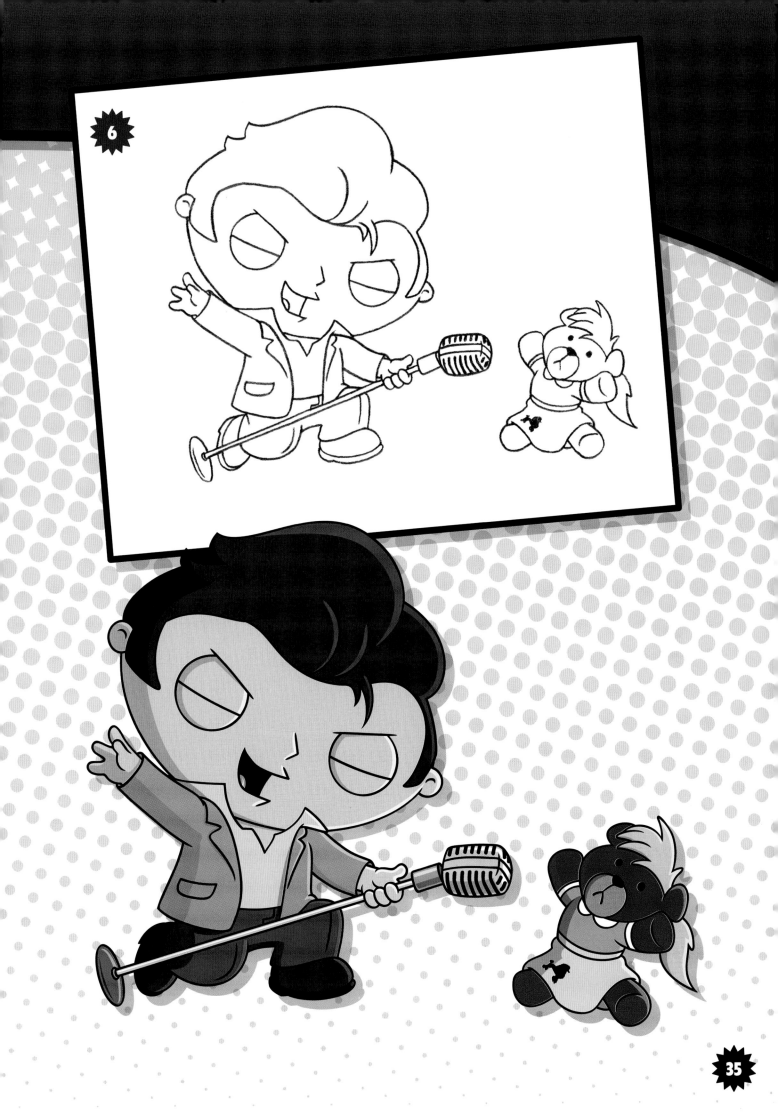

# 1960s

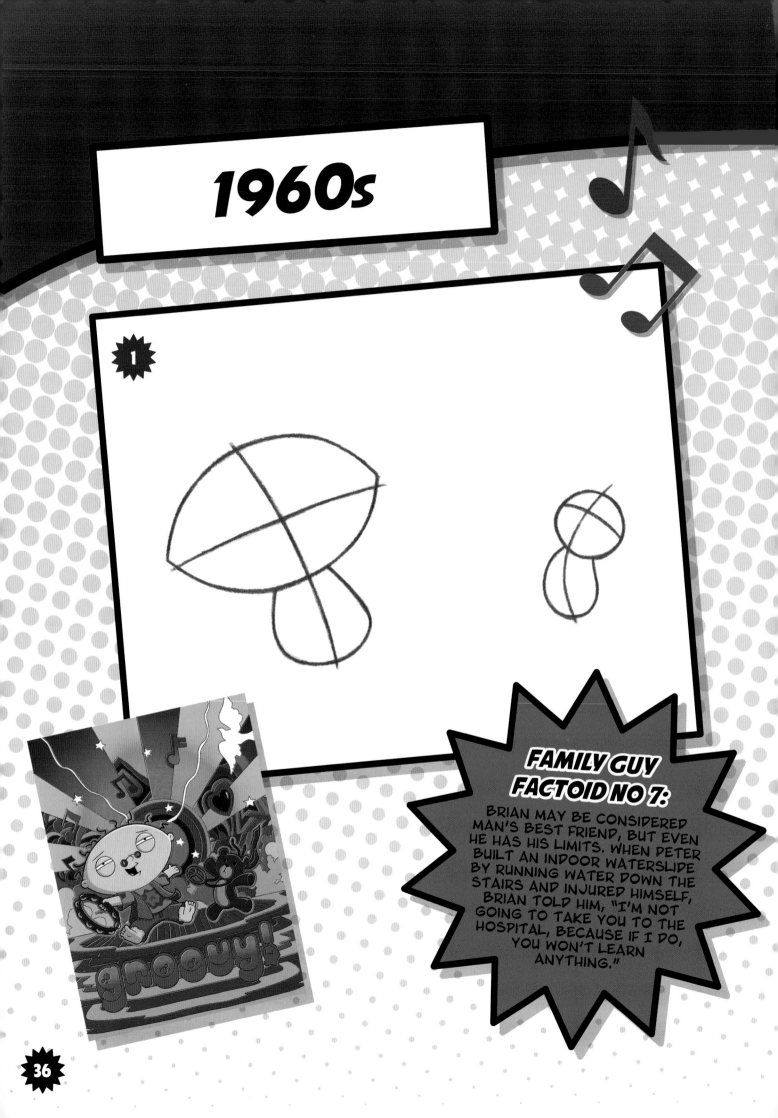

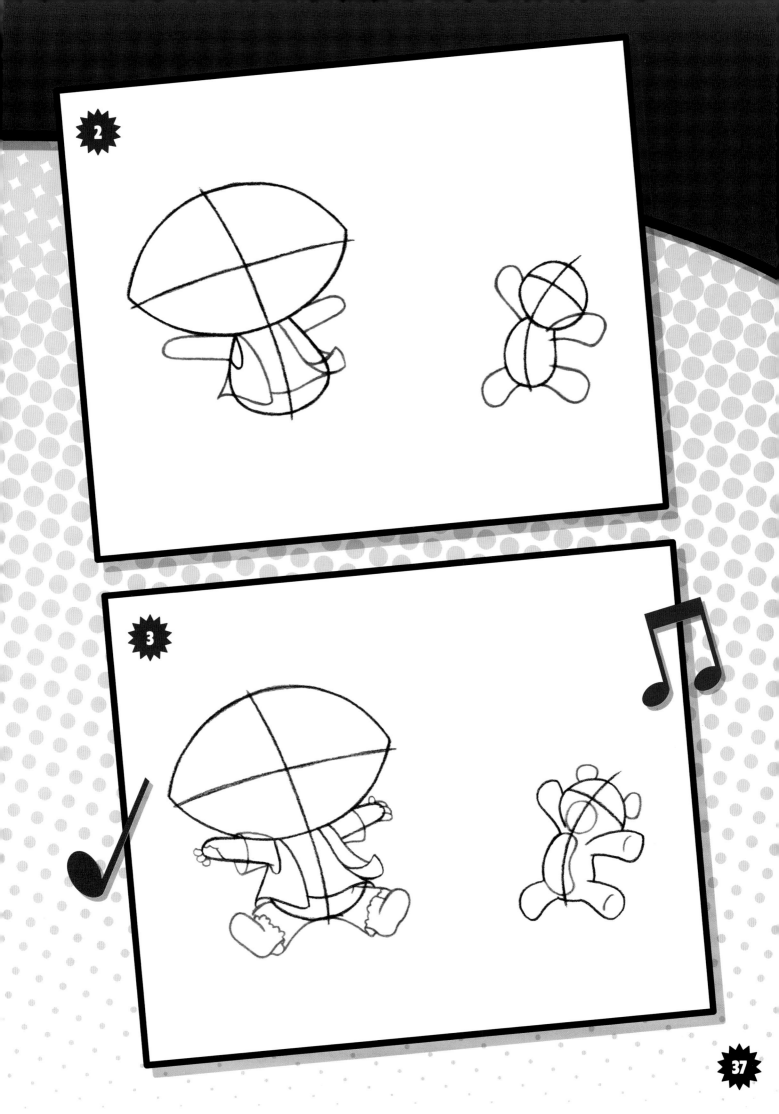

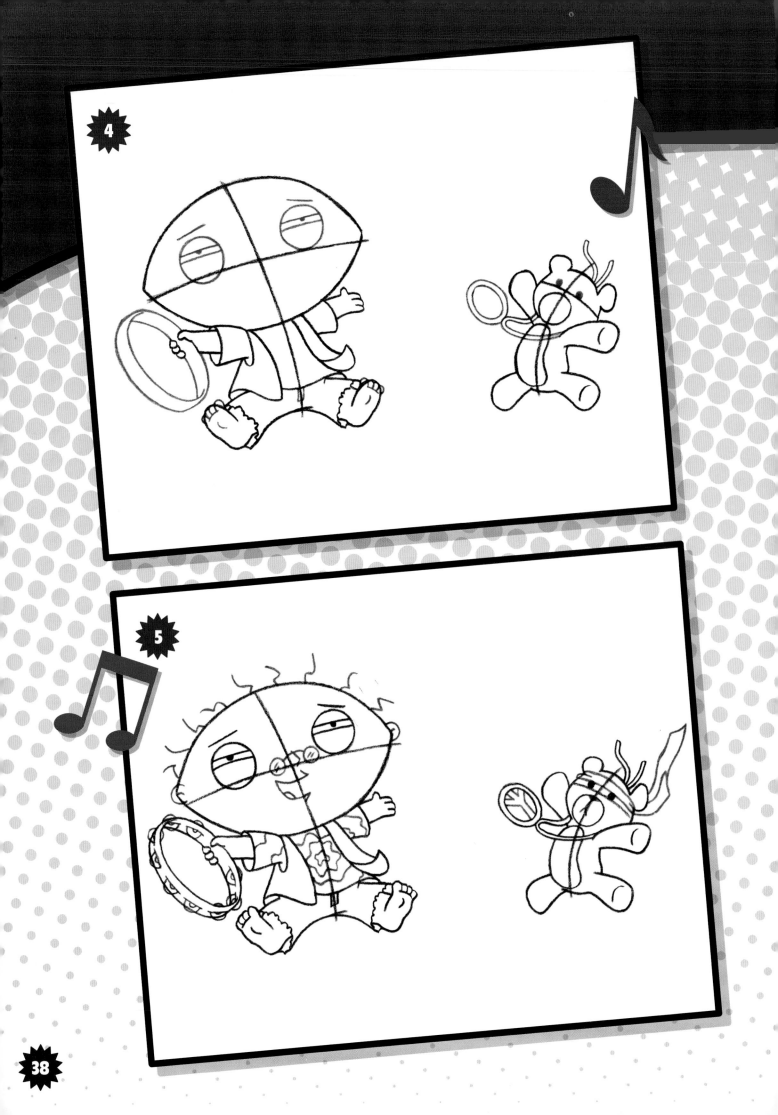

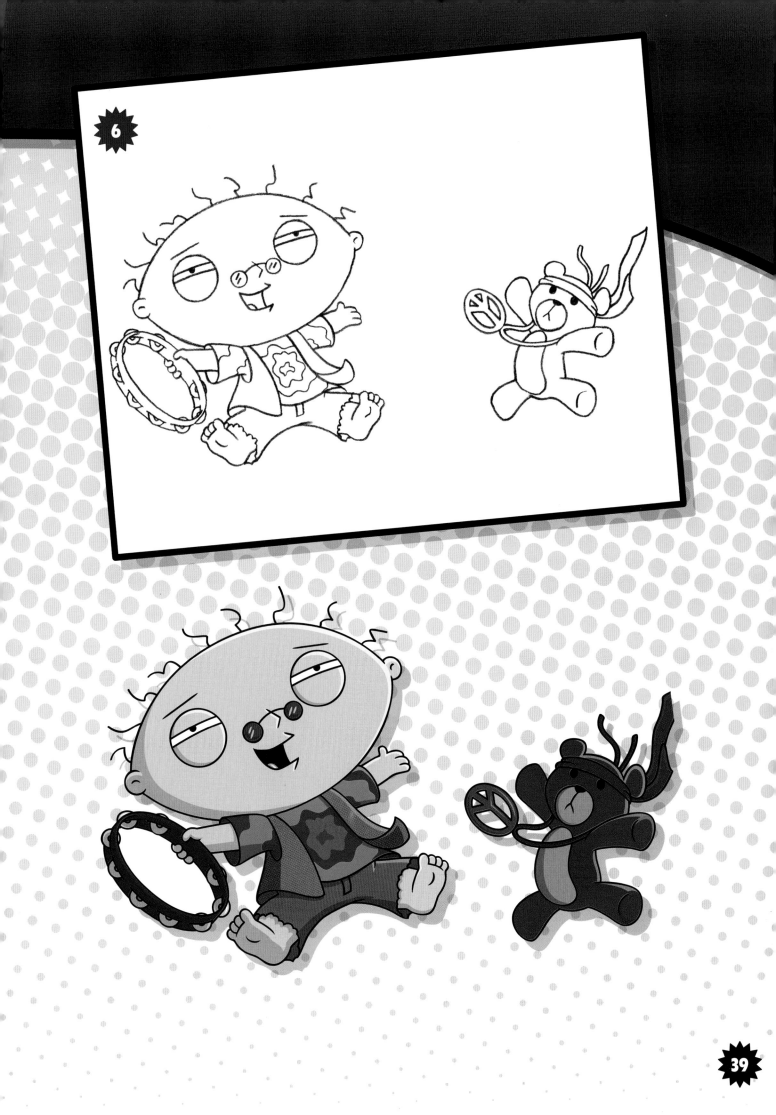

# 1980s

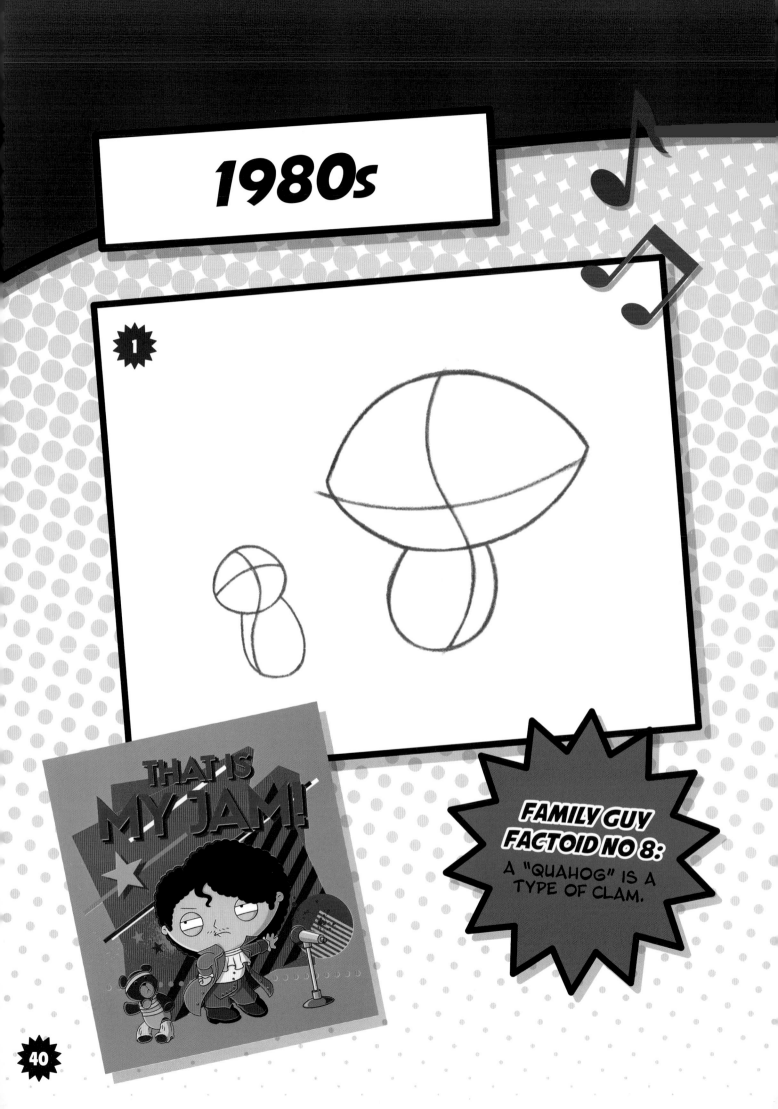

THAT IS MY JAM!

**FAMILY GUY FACTOID NO 8:** A "QUAHOG" IS A TYPE OF CLAM.

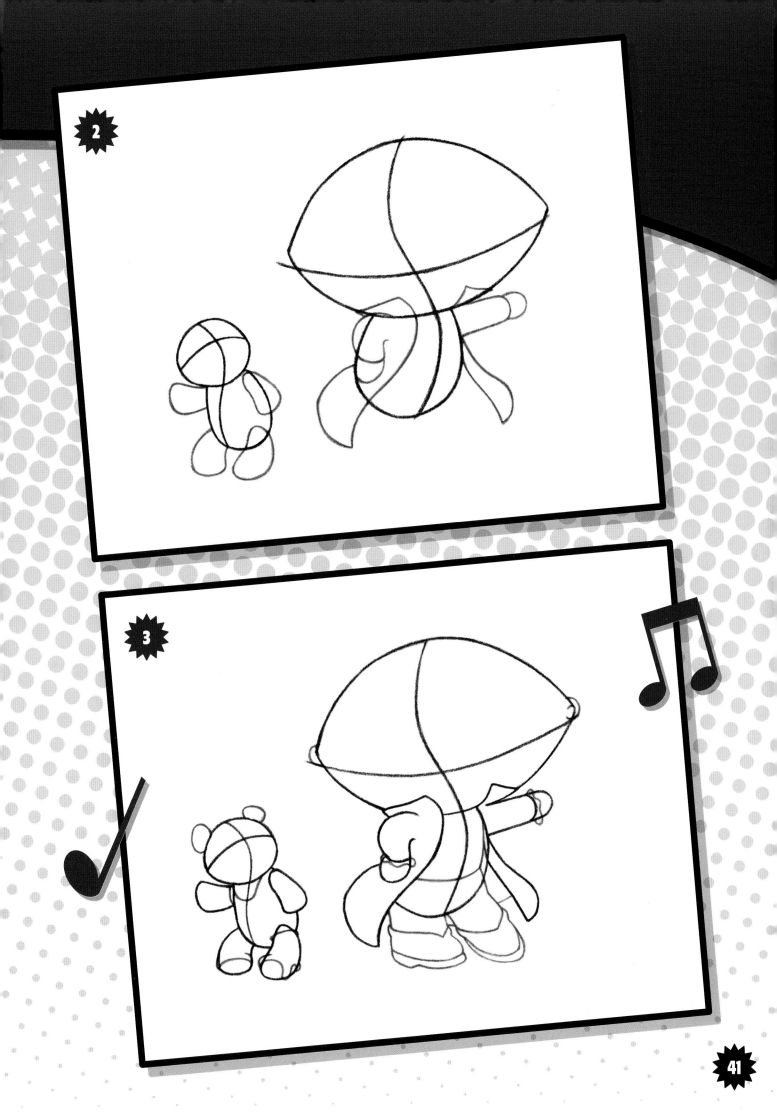

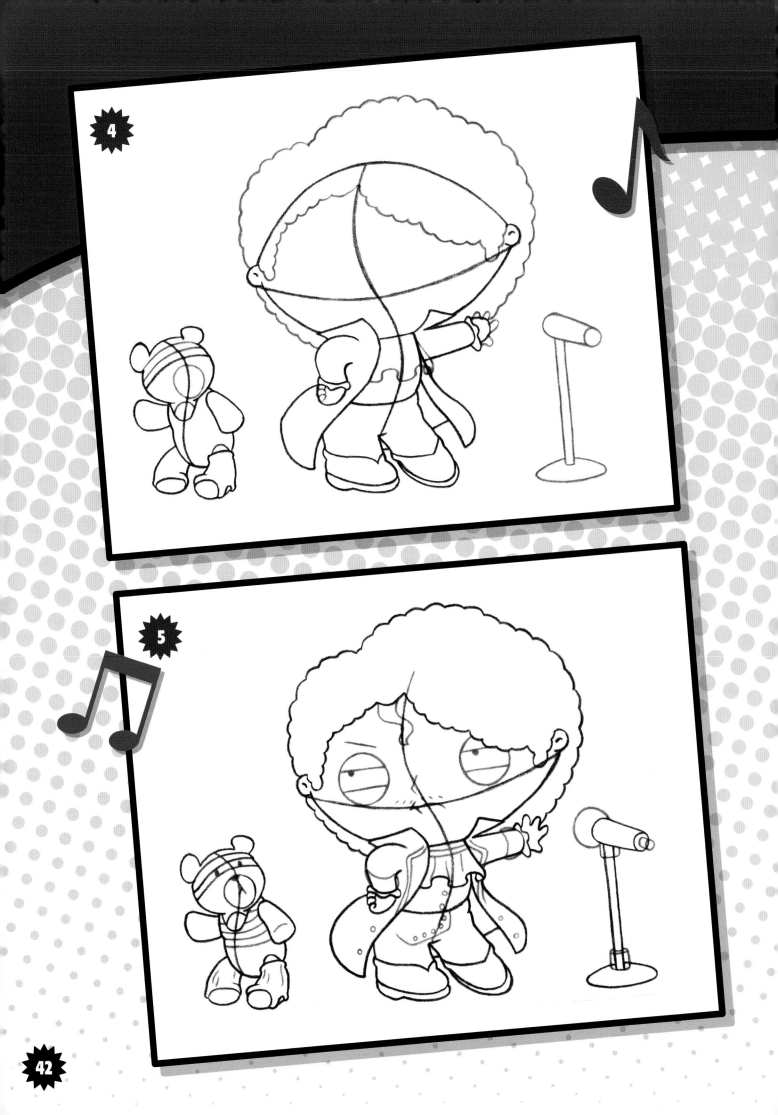

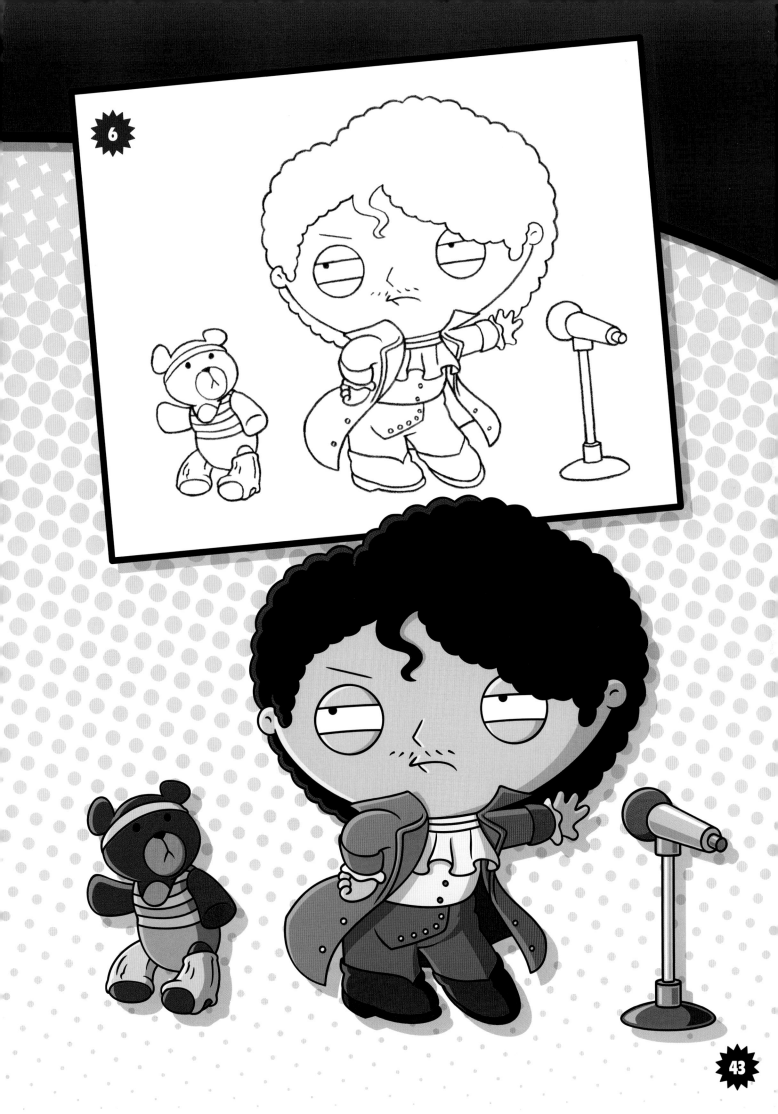

# 1990s

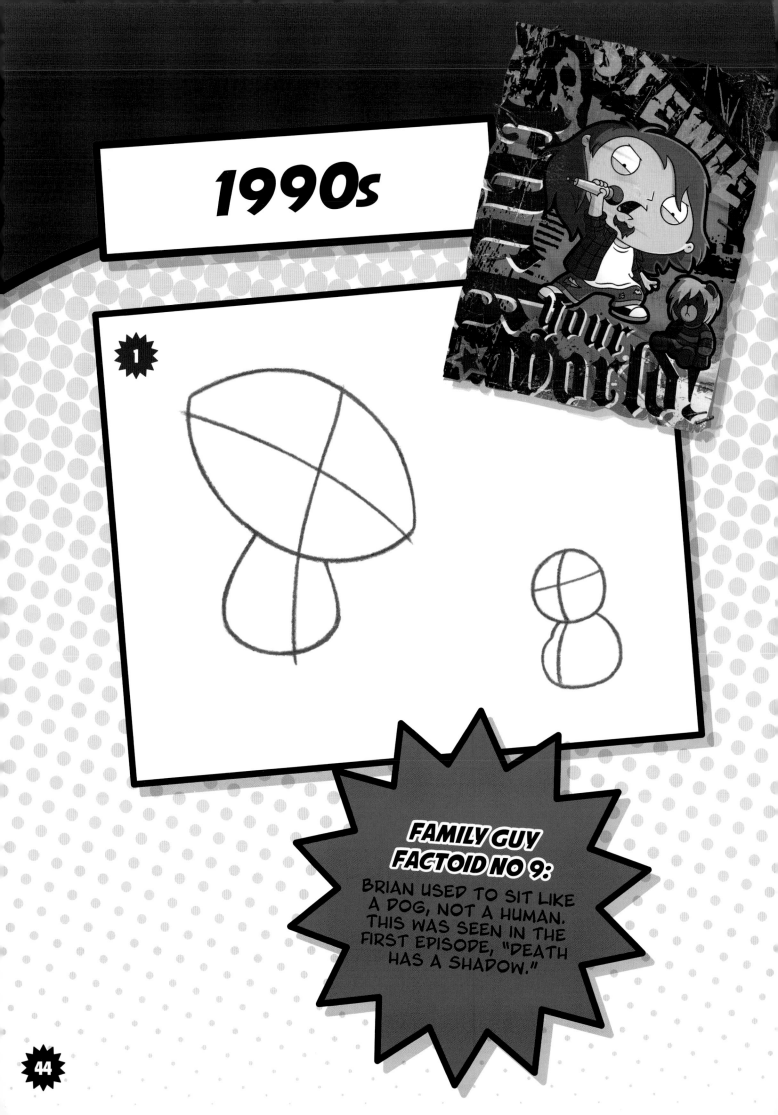

**1**

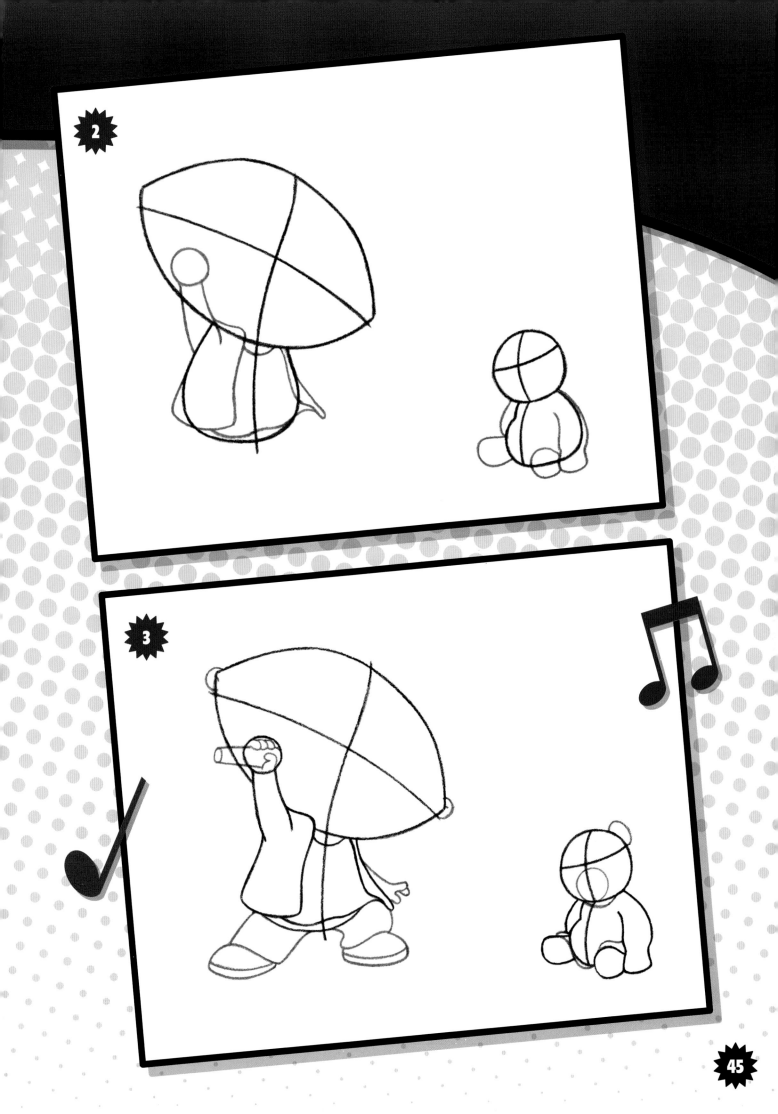

2

3

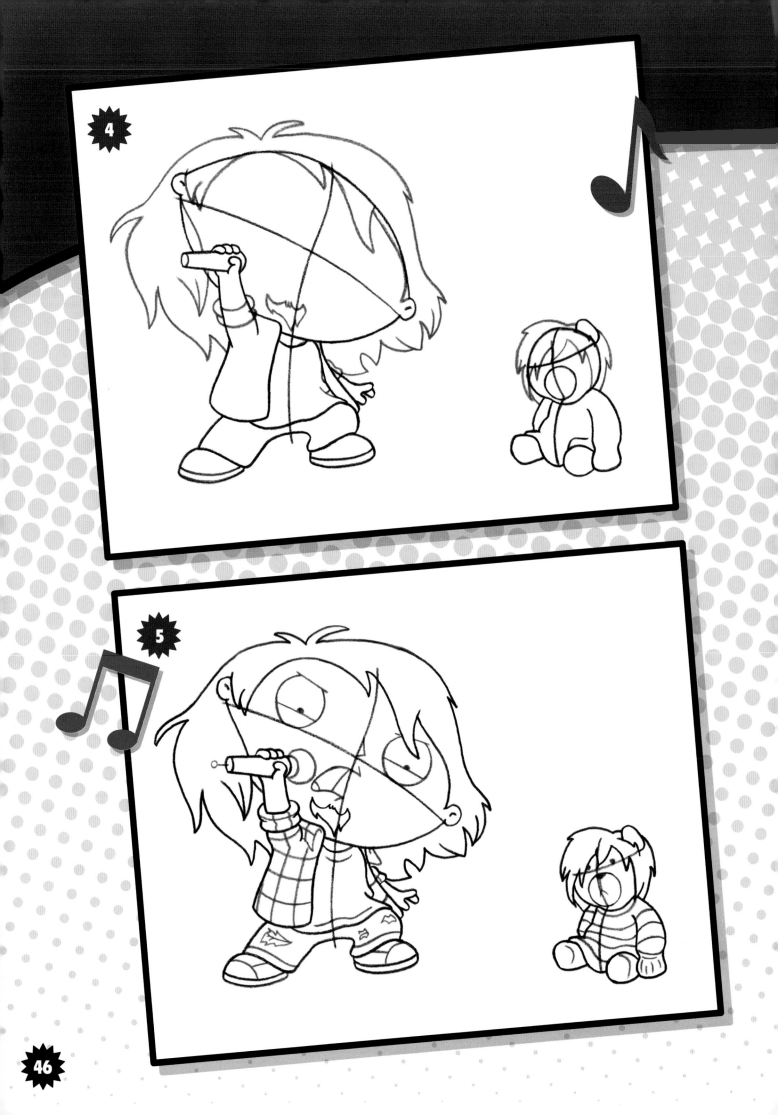

4

5

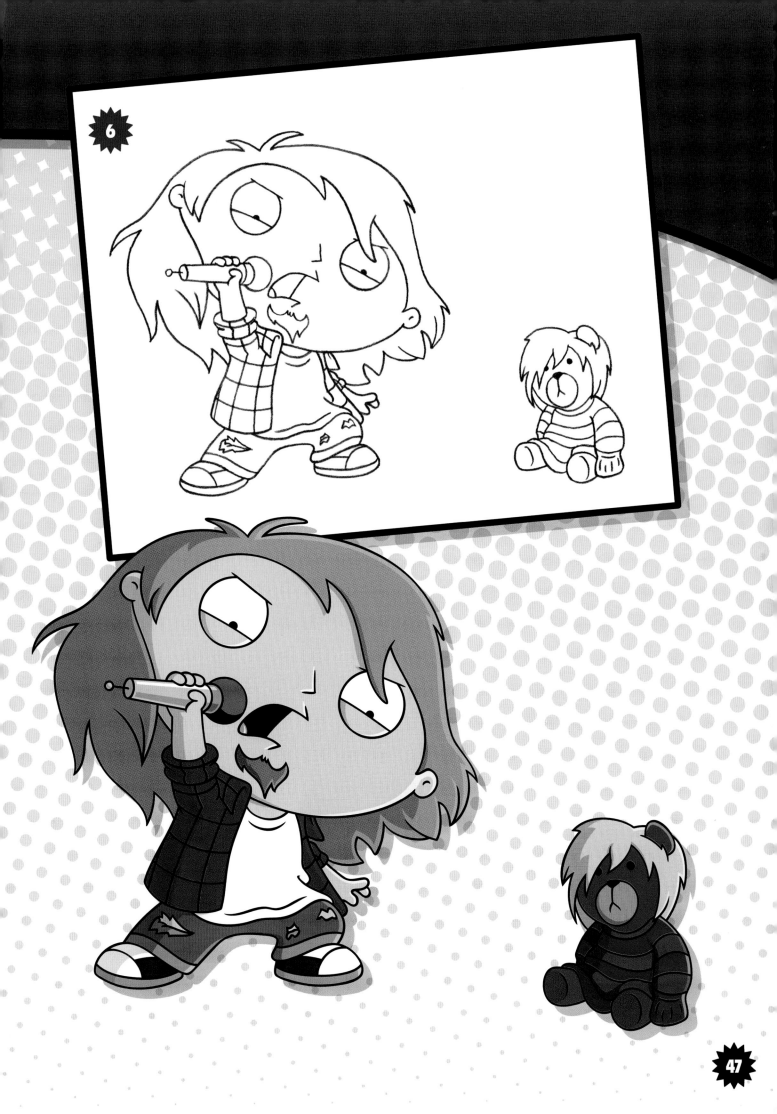

6

# ROAD TO...

**Workin' the Pole in VENICE**

## THE "ROAD TO..." EPISODES WERE INTRODUCED WITH "ROAD TO RHODE ISLAND," IN WHICH BRIAN AND STEWIE EMBARK ON A CROSS-COUNTRY TREK FROM CALIFORNIA BACK TO QUAHOG. SINCE THAT INAUGURAL JOURNEY, STEWIE AND BRIAN HAVE SHARED A VARIETY OF ADVENTURES ACROSS THE PLANET AND EVEN THROUGH TIME! IN THIS SECTION, WE TAKE A PEEK AT THEIR PASSPORTS FROM SEASON 3'S "ROAD TO EUROPE," INCLUDING DESTINATIONS SUCH AS GERMANY, ITALY, SWITZERLAND, AMSTERDAM, AND LONDON. WE THEN FAST-FORWARD TO SEASON 7'S "ROAD TO GERMANY," WHERE THE TWO TIME-TRAVEL THROUGH THE NAZI REGIME BY U-BOAT. WE CAN GUARANTEE THIS IS ONE INSANE ROAD TO TRAVEL!

**Greetings From ~~LEANING TOWER OF~~ PISA**

**Feeling 'Alphorny' in SWITZERLAND**

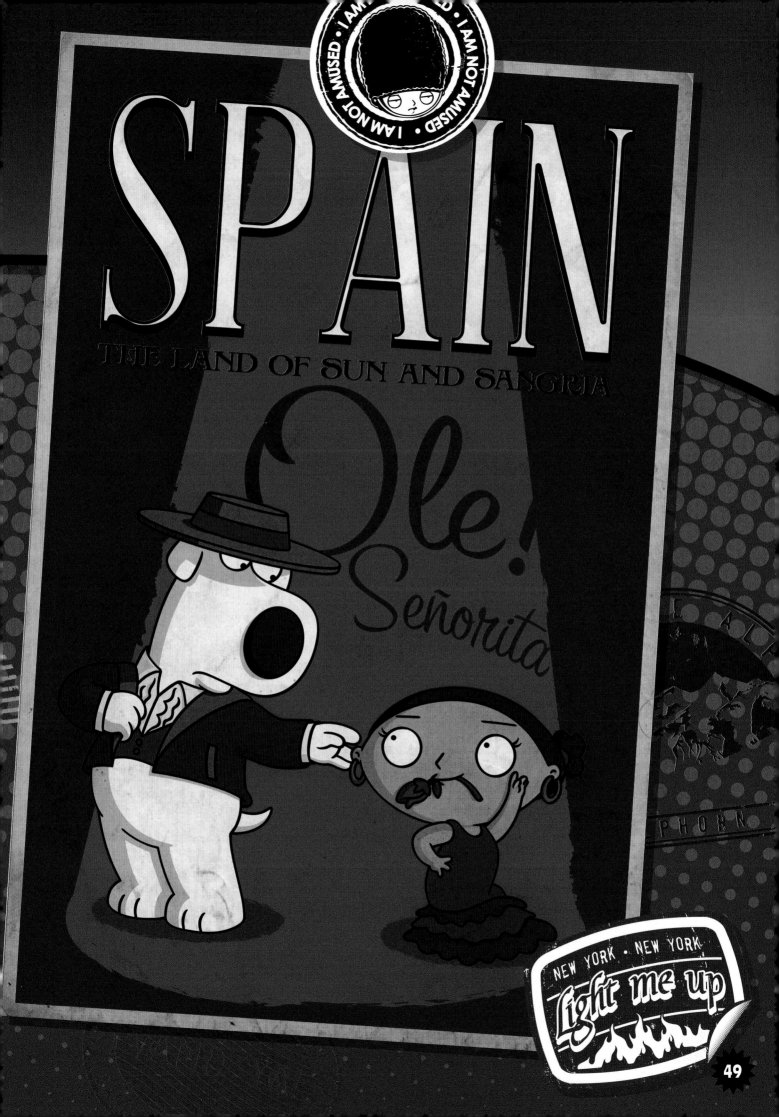

# LONDON

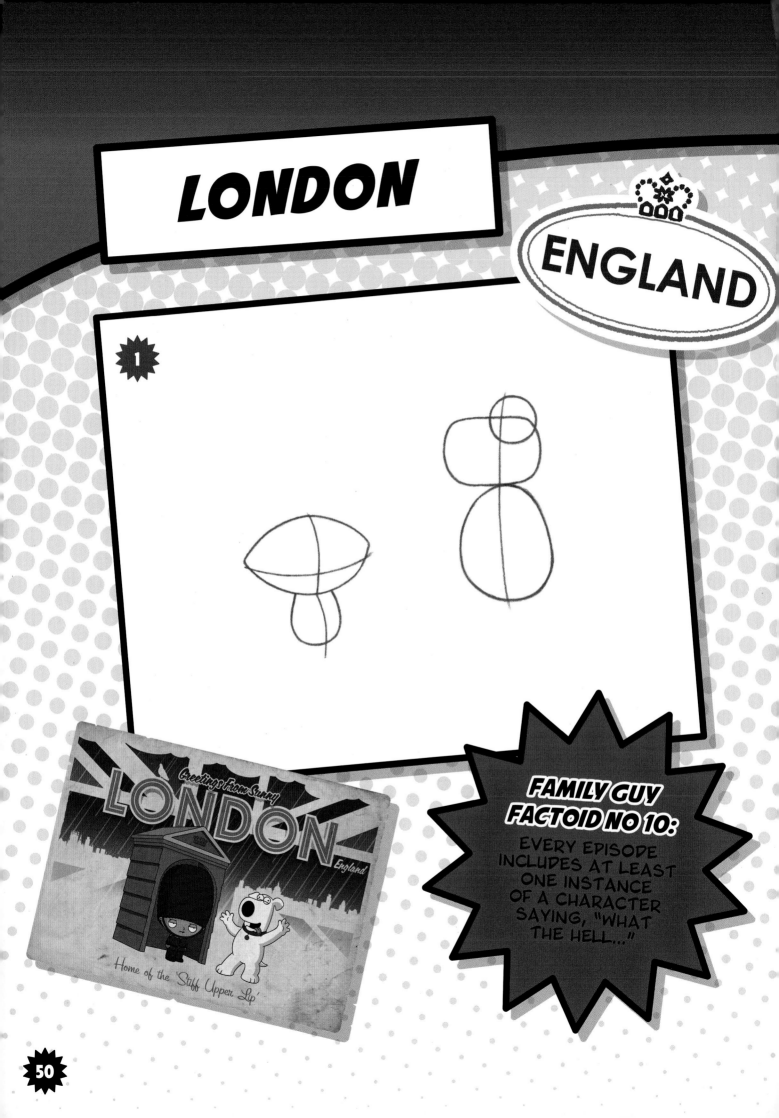

**1**

Greetings From Sunny
LONDON
England

Home of the 'Stiff Upper Lip'

**FAMILY GUY FACTOID NO 10:**
EVERY EPISODE INCLUDES AT LEAST ONE INSTANCE OF A CHARACTER SAYING, "WHAT THE HELL..."

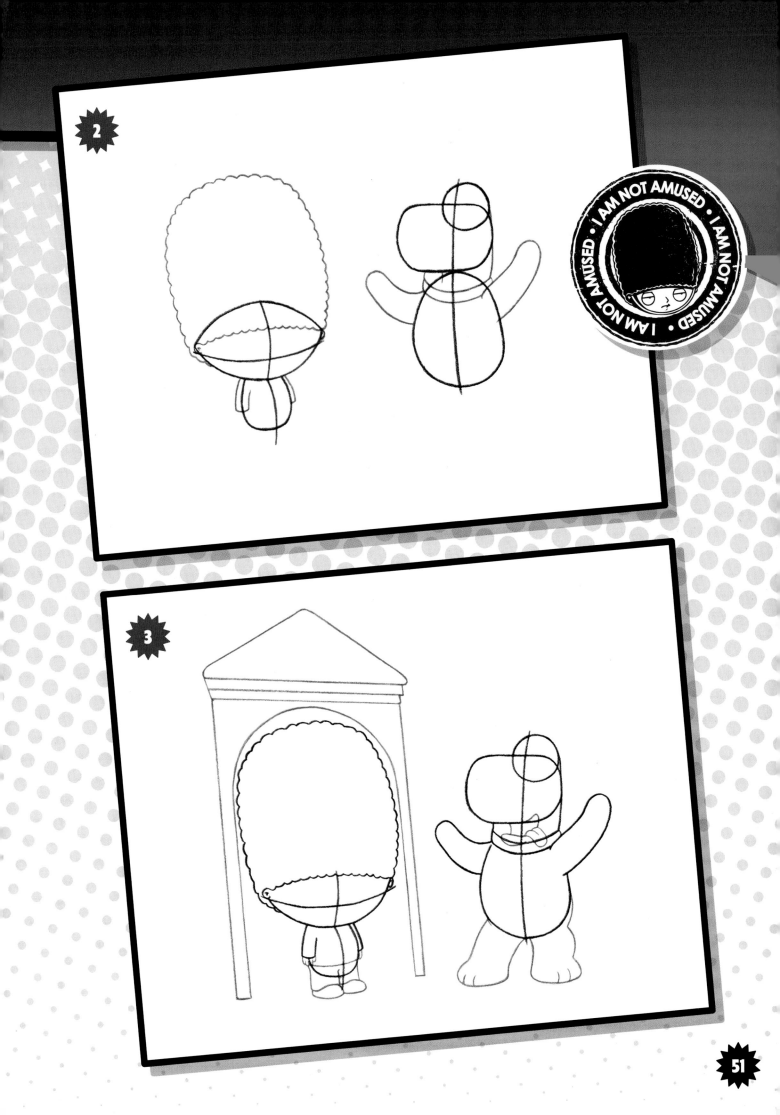

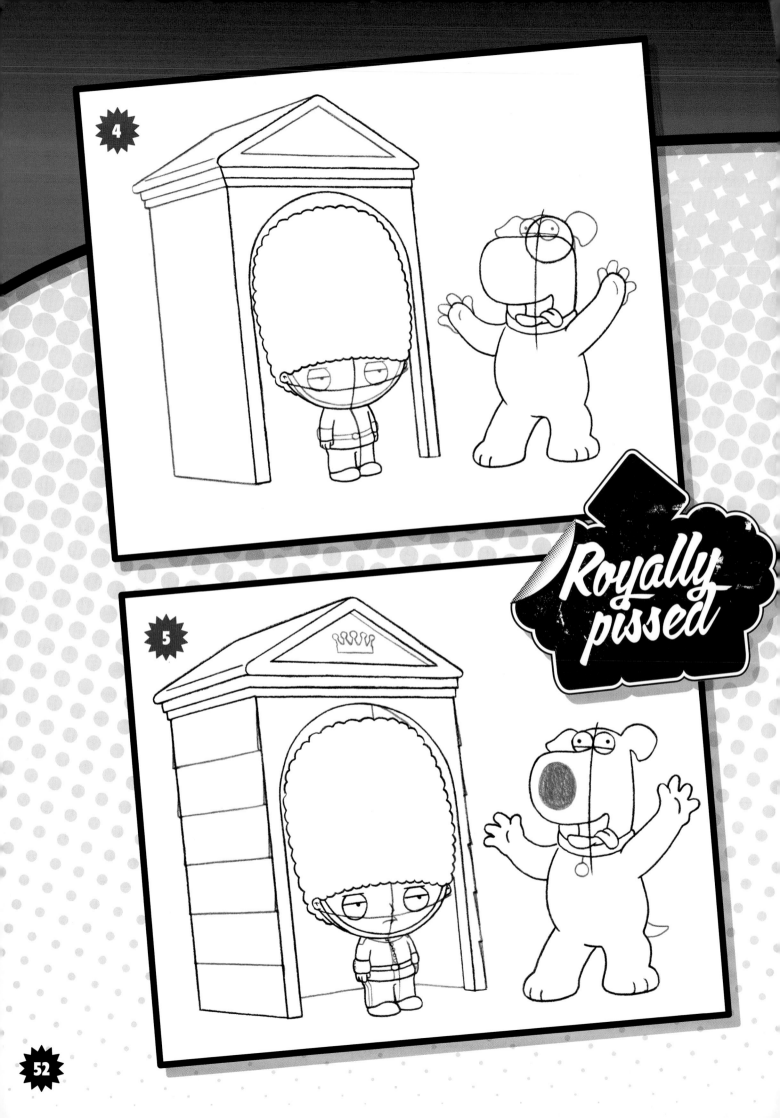

Royally pissed

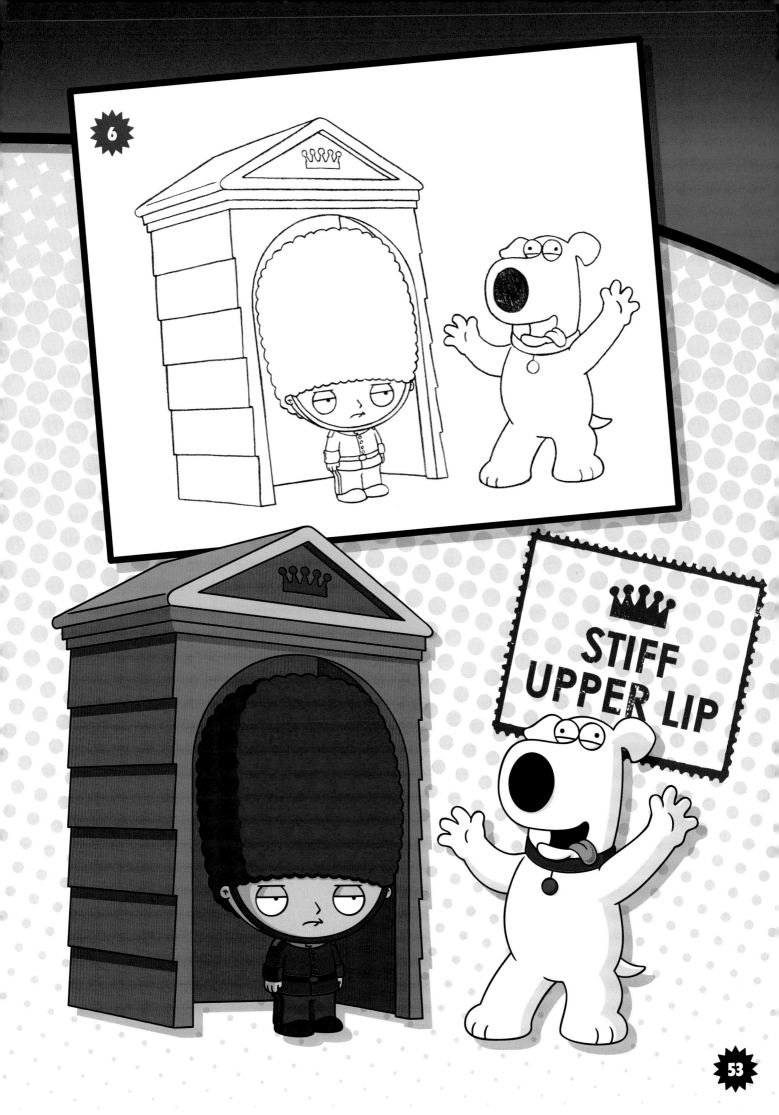

STIFF
UPPER LIP

# NEW YORK CITY

U.S.A

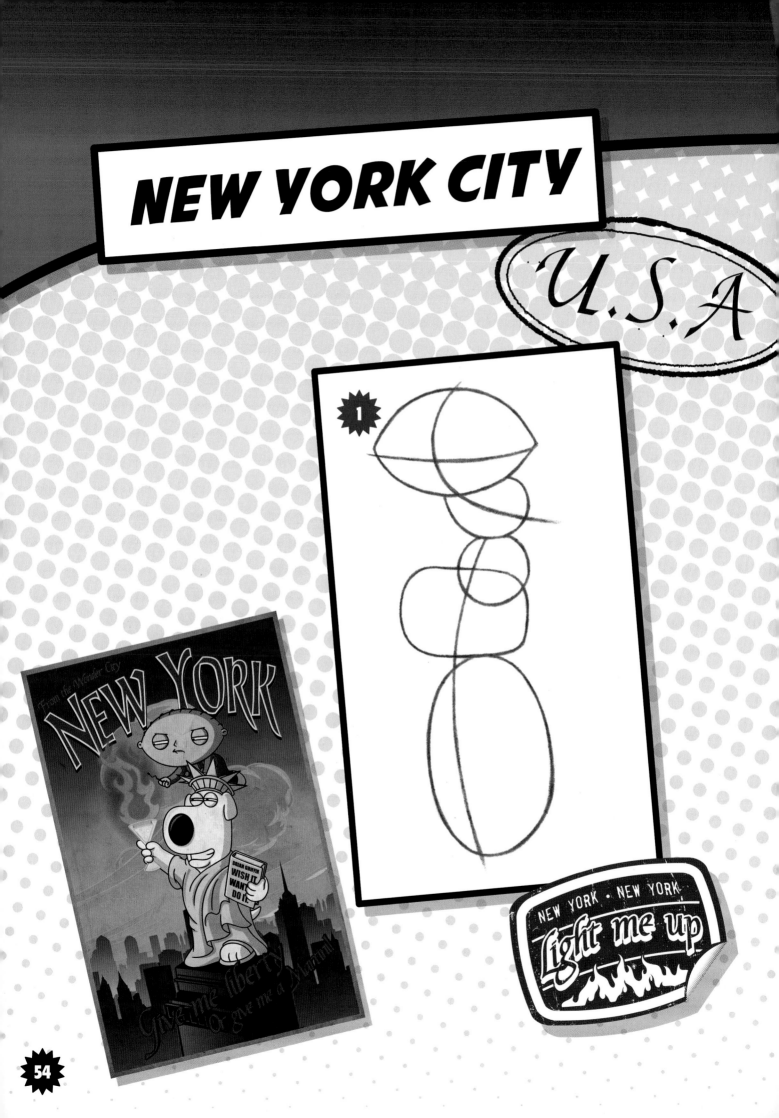

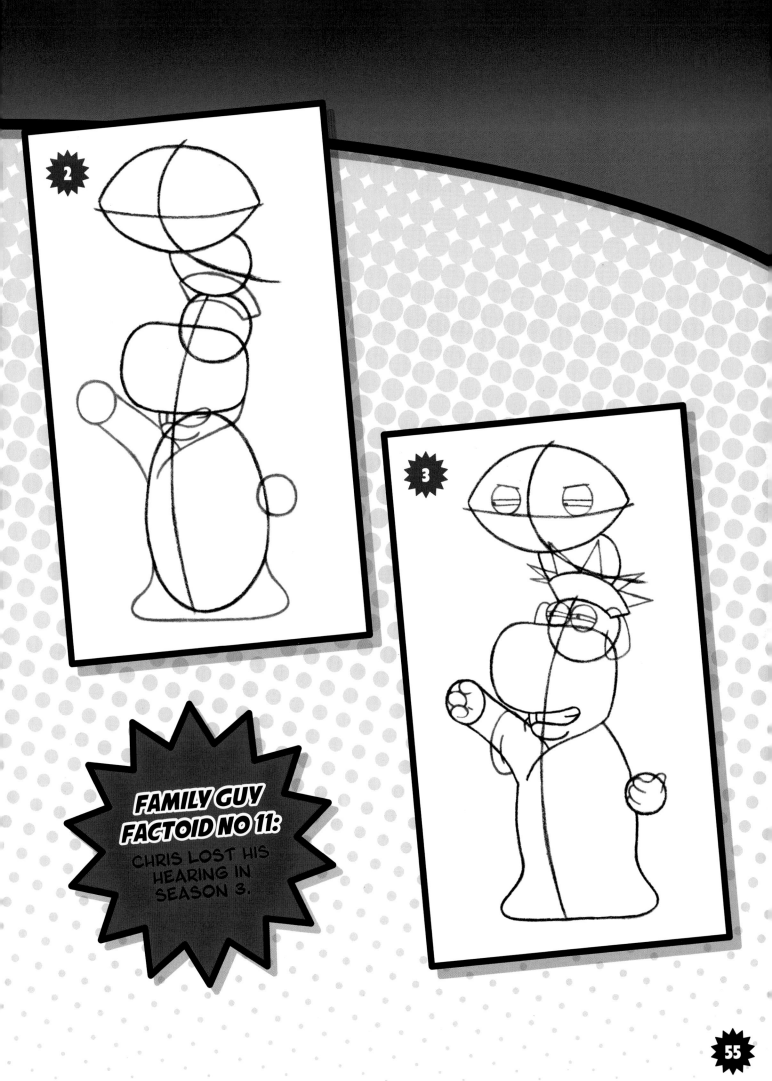

**FAMILY GUY FACTOID NO 11:**

CHRIS LOST HIS HEARING IN SEASON 3.

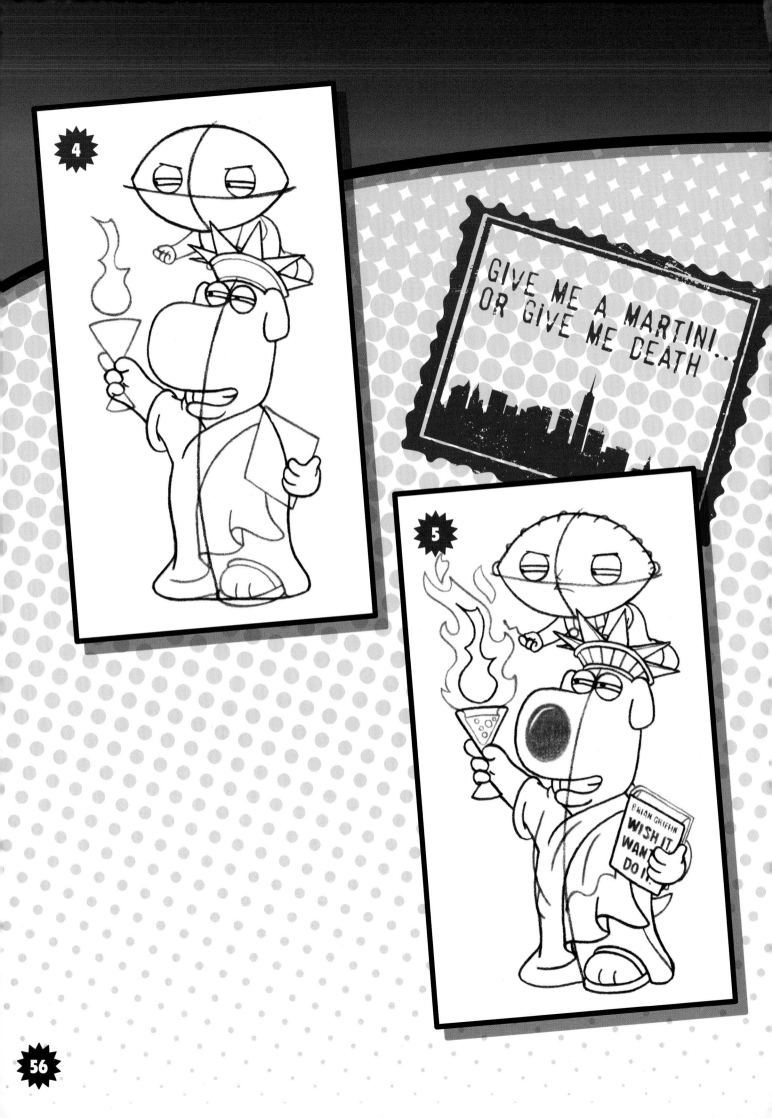

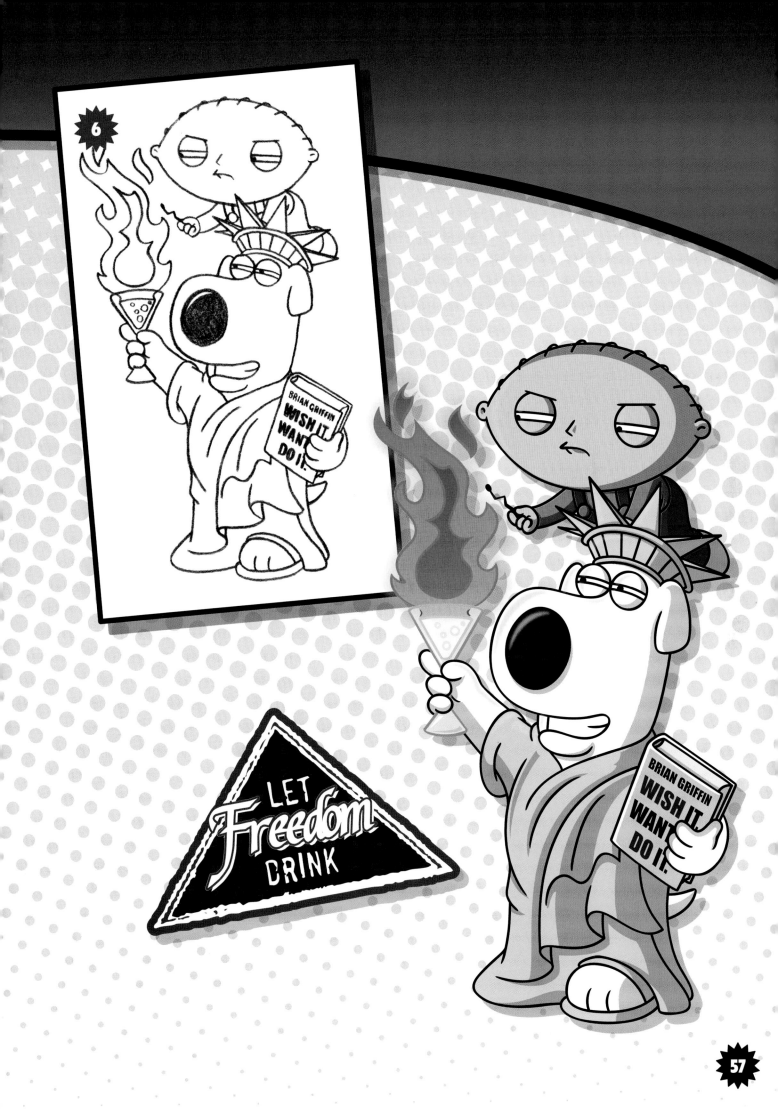

# SPAIN

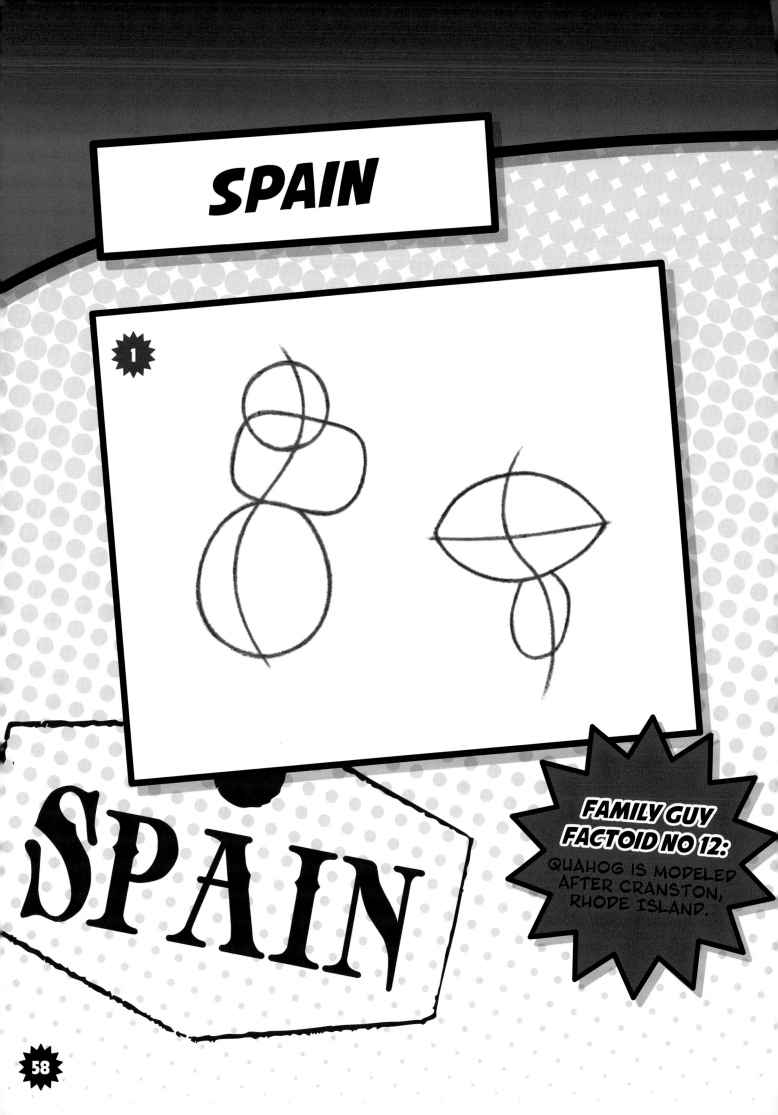

**FAMILY GUY FACTOID NO 12:** QUAHOG IS MODELED AFTER CRANSTON, RHODE ISLAND.

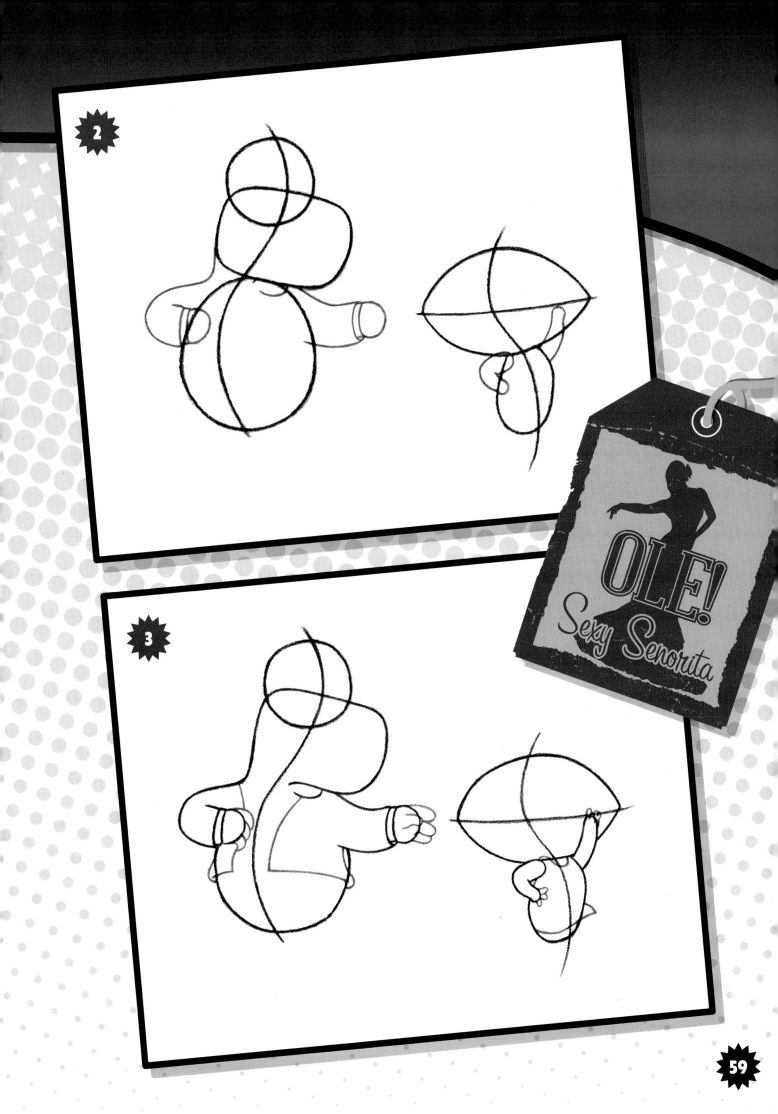

**2**

**3**

OLE!
*Sexy Senorita*

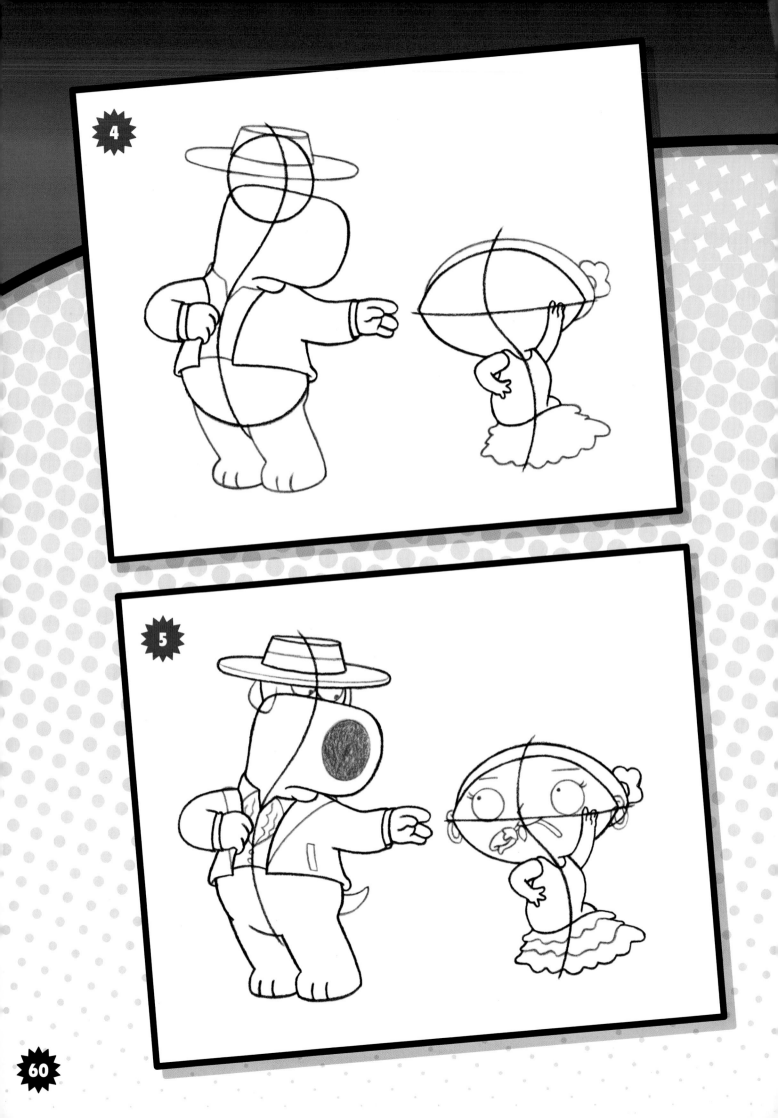

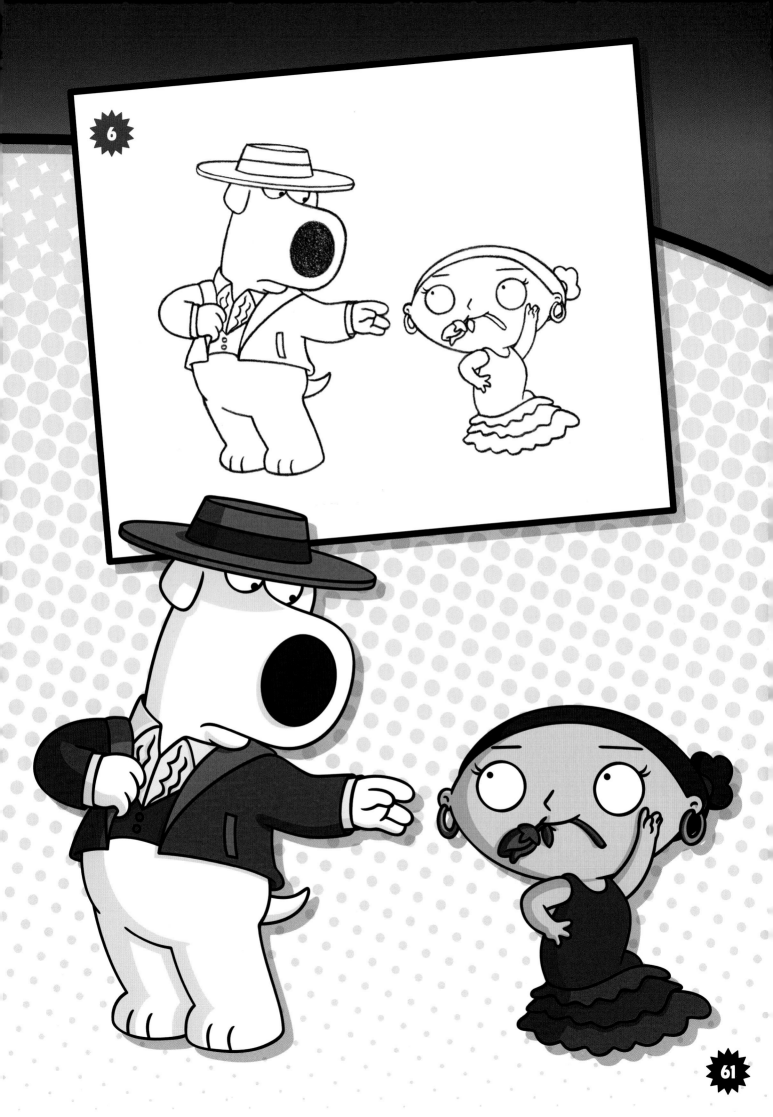

# SWITZERLAND

**2**

TOOTIN'
*My Own Horn*
IN SWITZERLAND

**3**

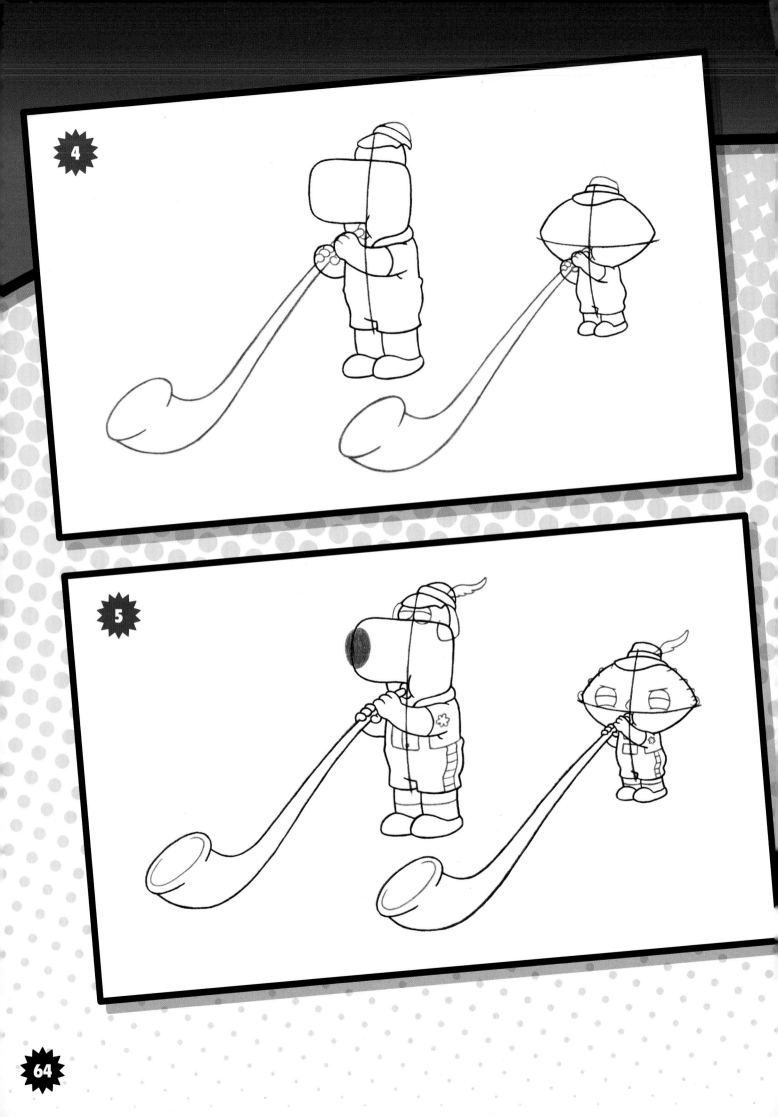

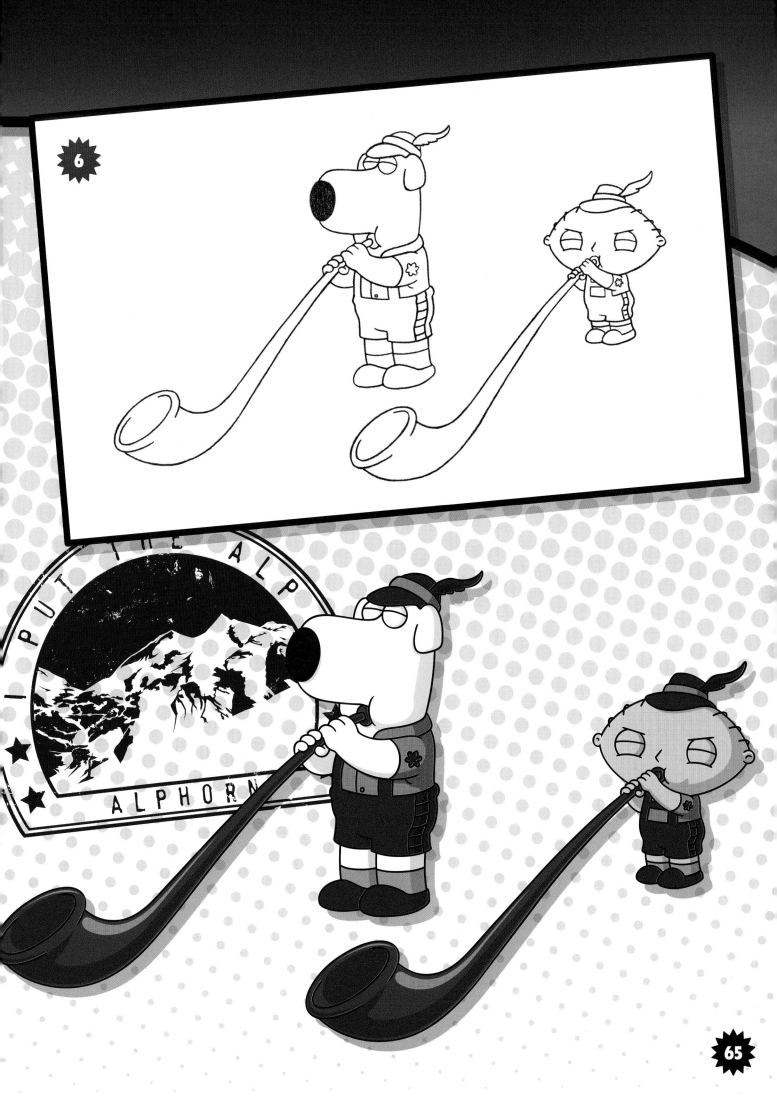

# ITALY: PISA

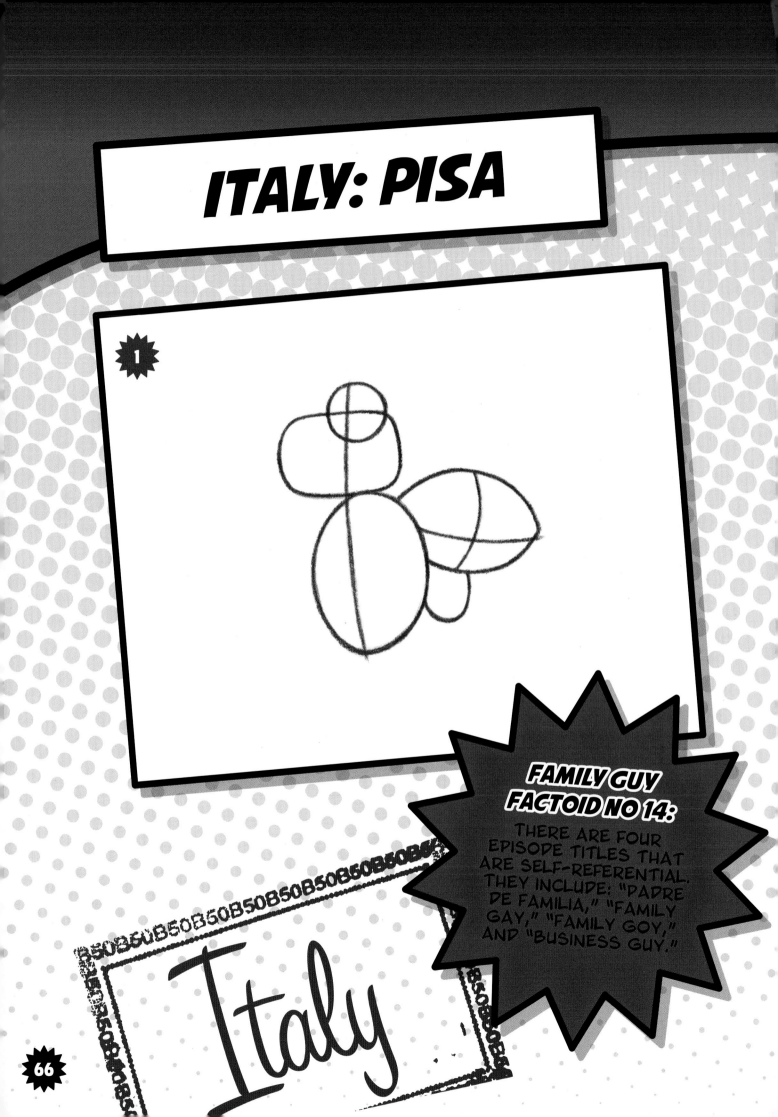

**1**

Italy

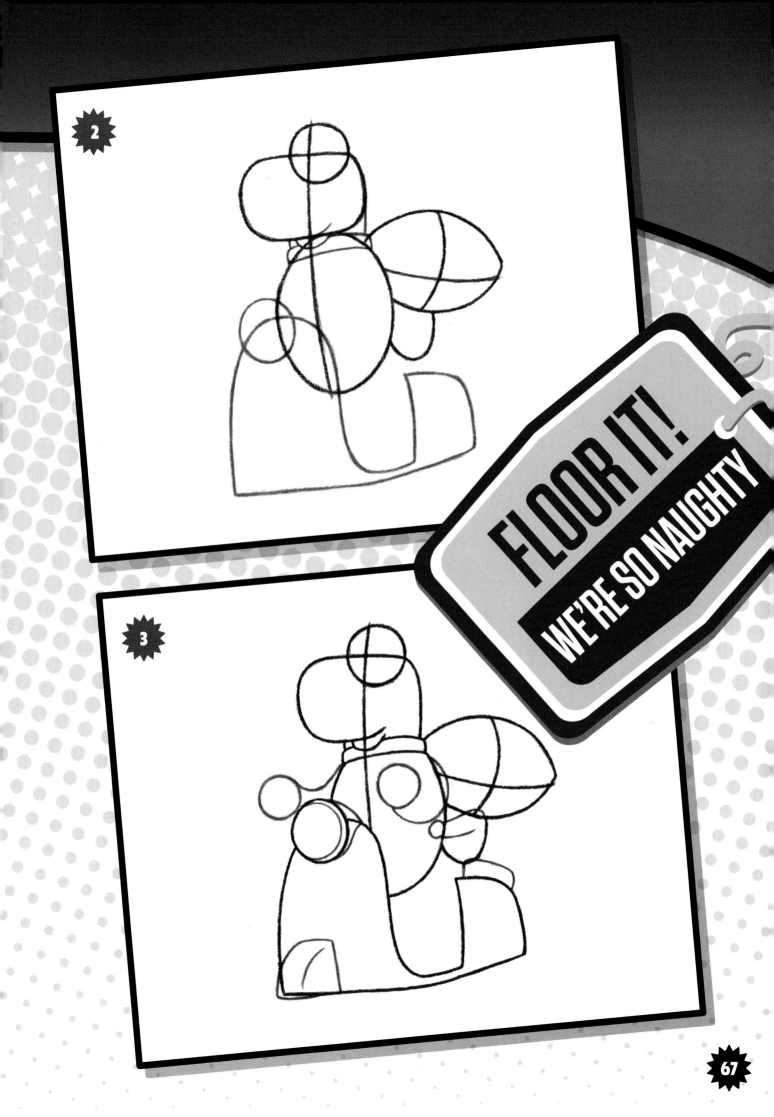

**2**

**3**

FLOOR IT!:
WE'RE SO NAUGHTY

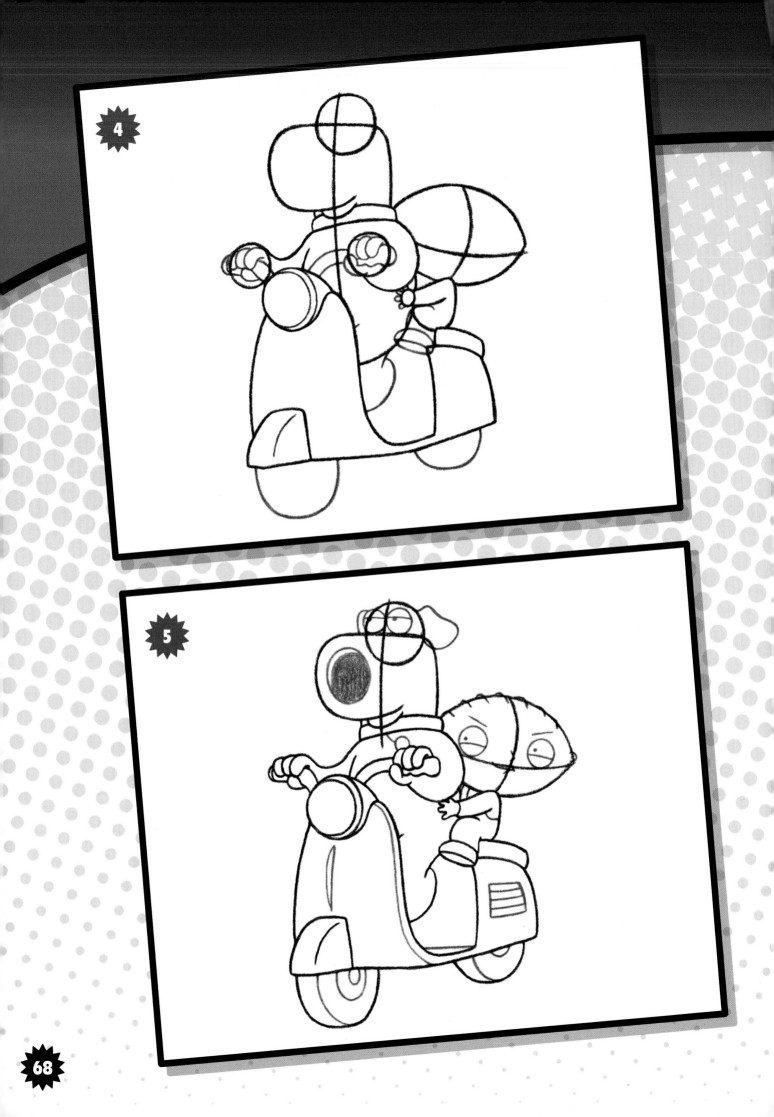

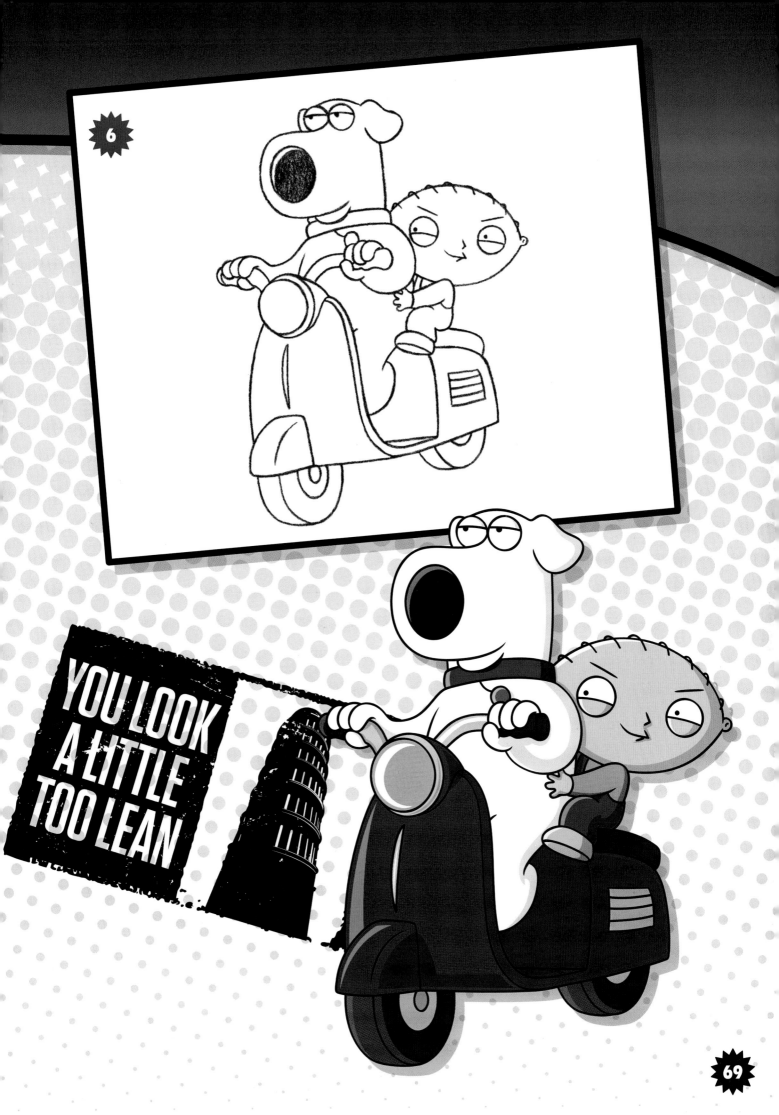

# ITALY: VENICE

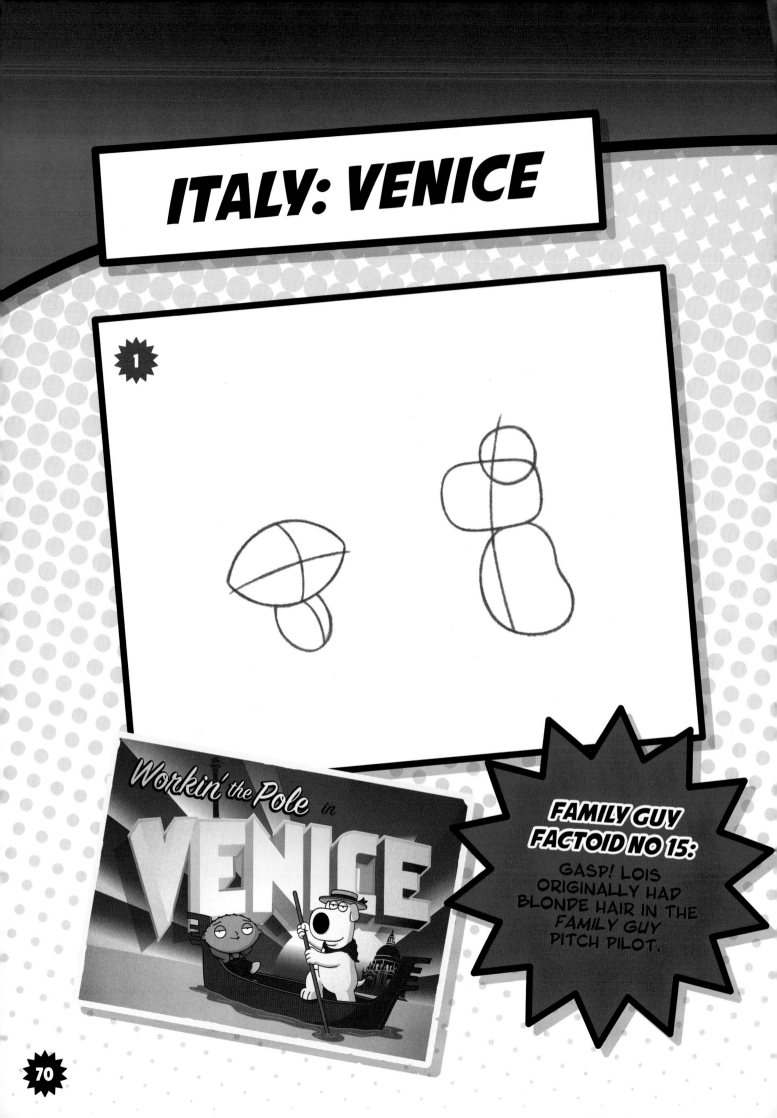

Workin' the Pole in **VENICE**

**FAMILY GUY FACTOID NO 15:**

GASP! LOIS ORIGINALLY HAD BLONDE HAIR IN THE FAMILY GUY PITCH PILOT.

**2**

**3**

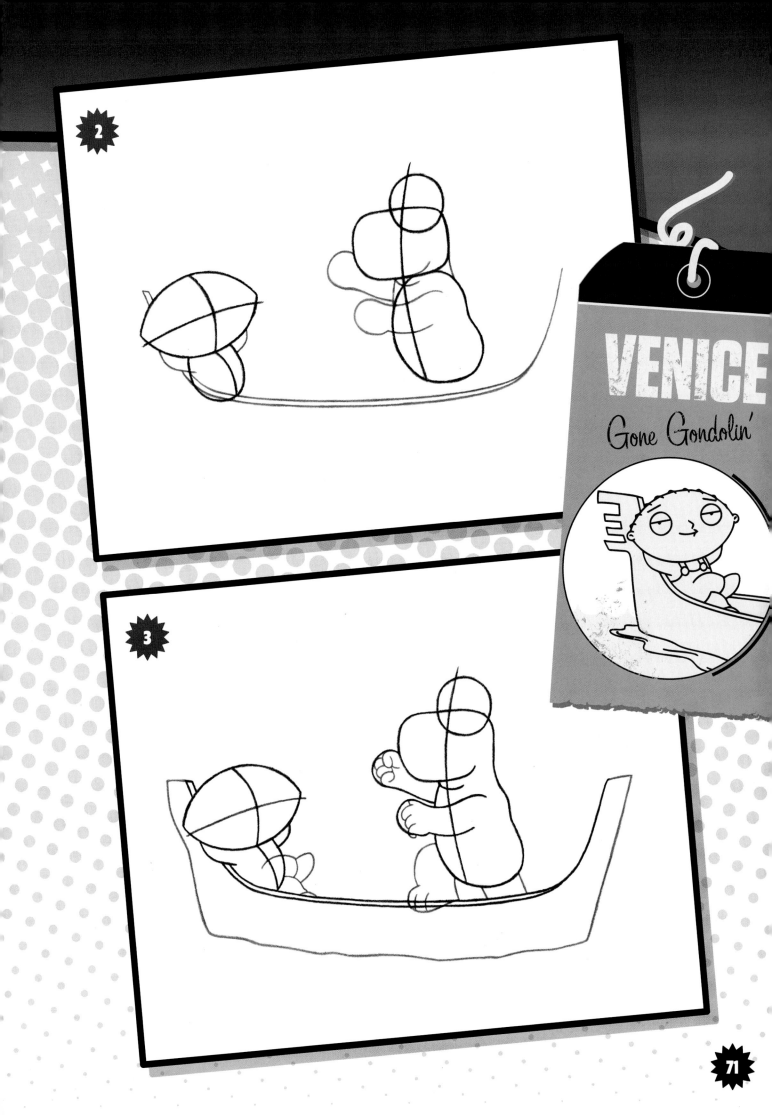

VENICE

*Gone Gondolin'*

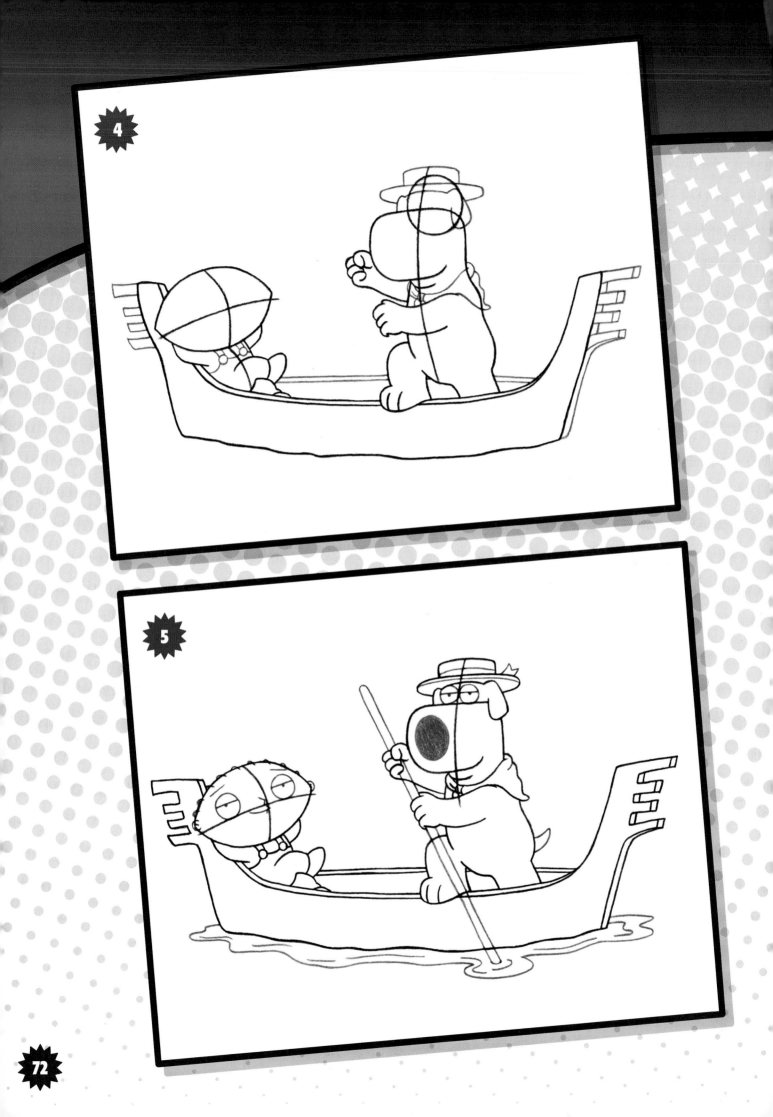

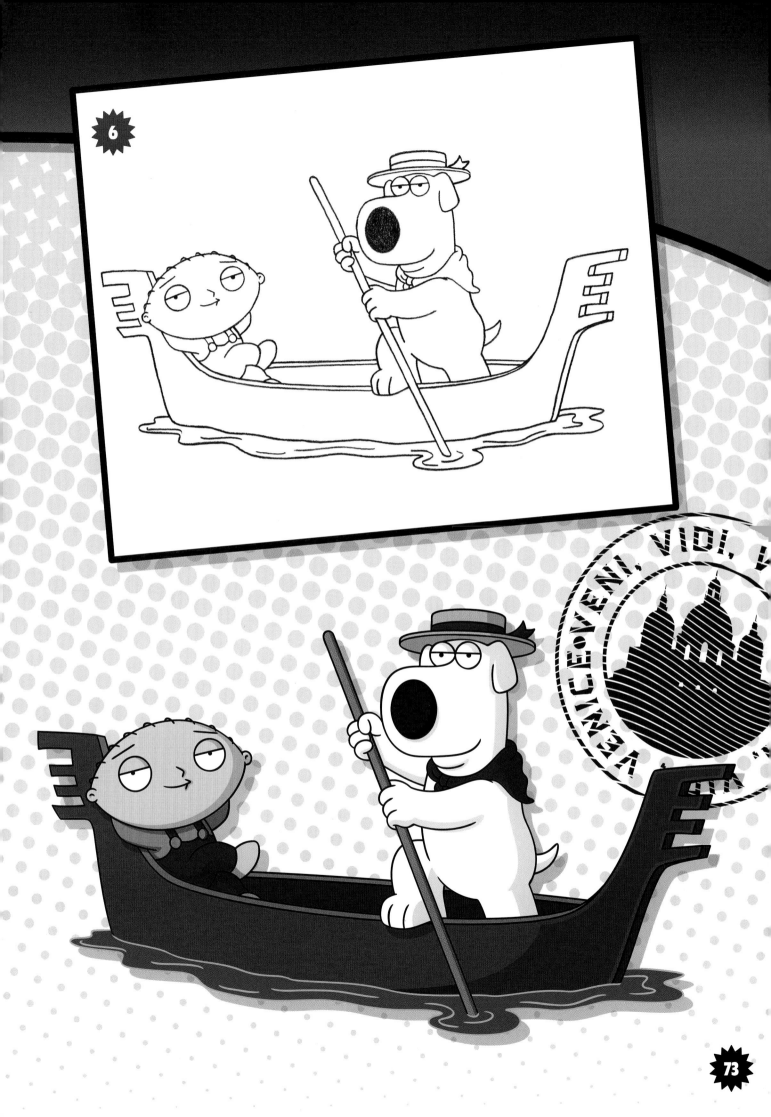

# GERMANY

**1**

Oktoberfest

Goin' German

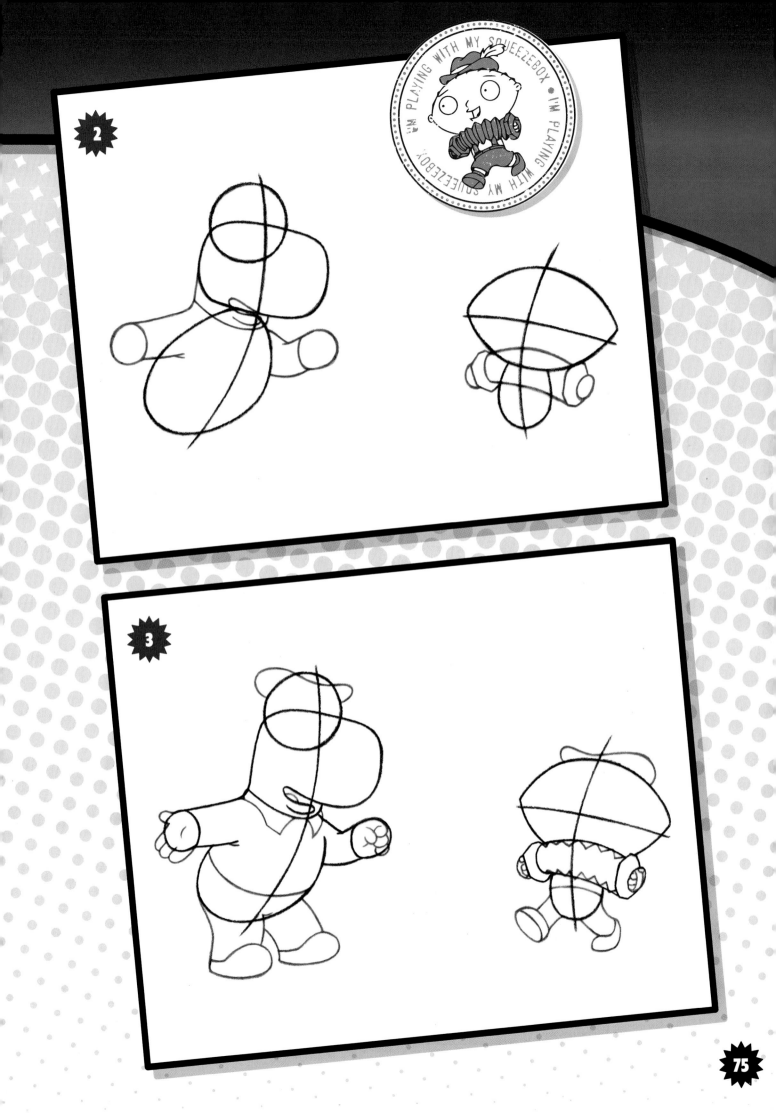

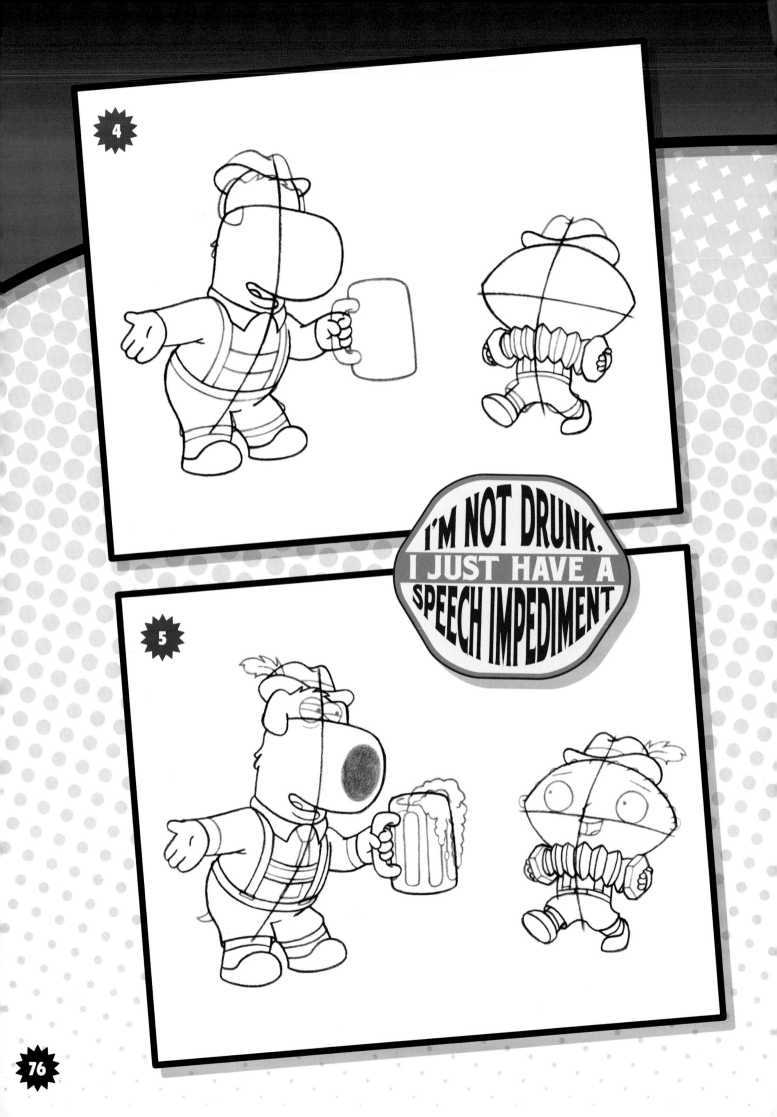

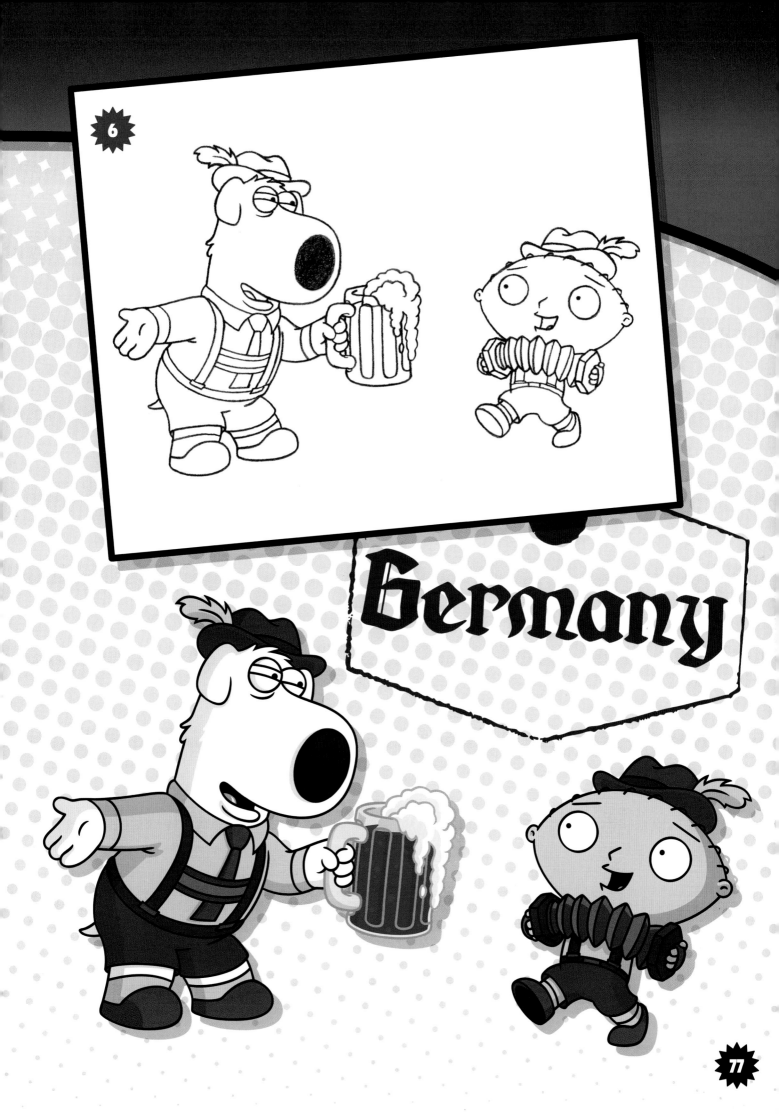

# GREECE

**1**

GETTING STONED IN

GREECE

What the Zeus!

GREECE

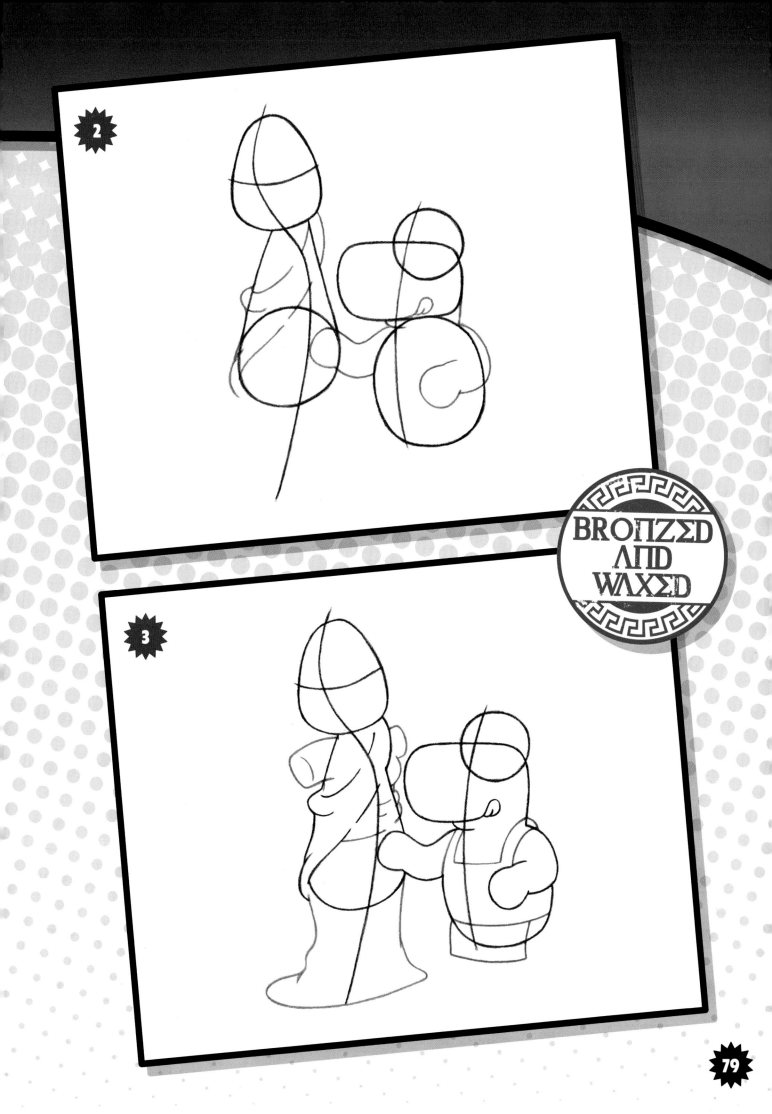

BROΠZED AΠD WAXED

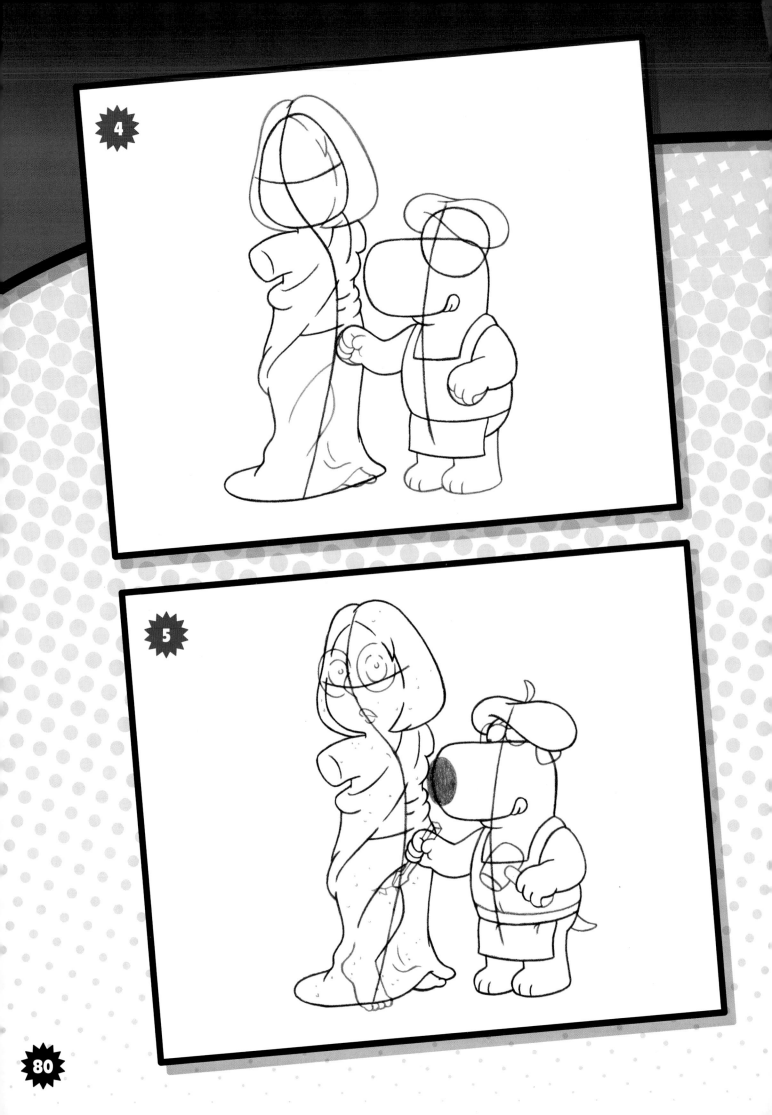

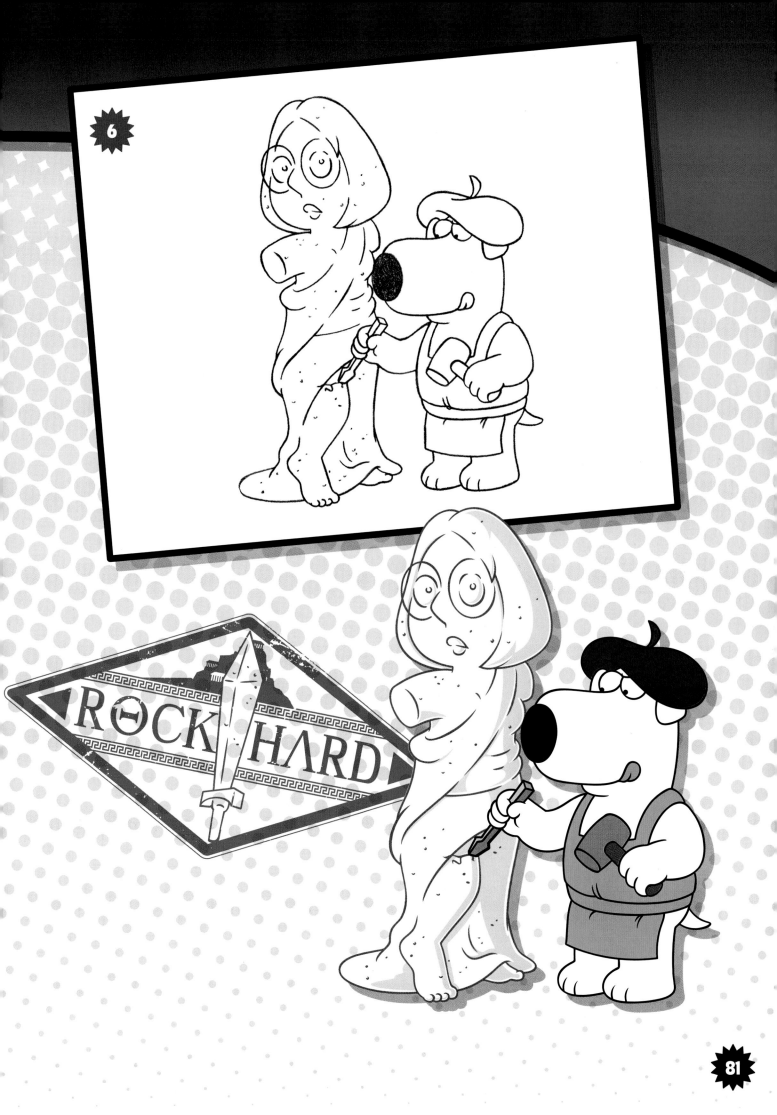

# MIDDLE EAST

**1**

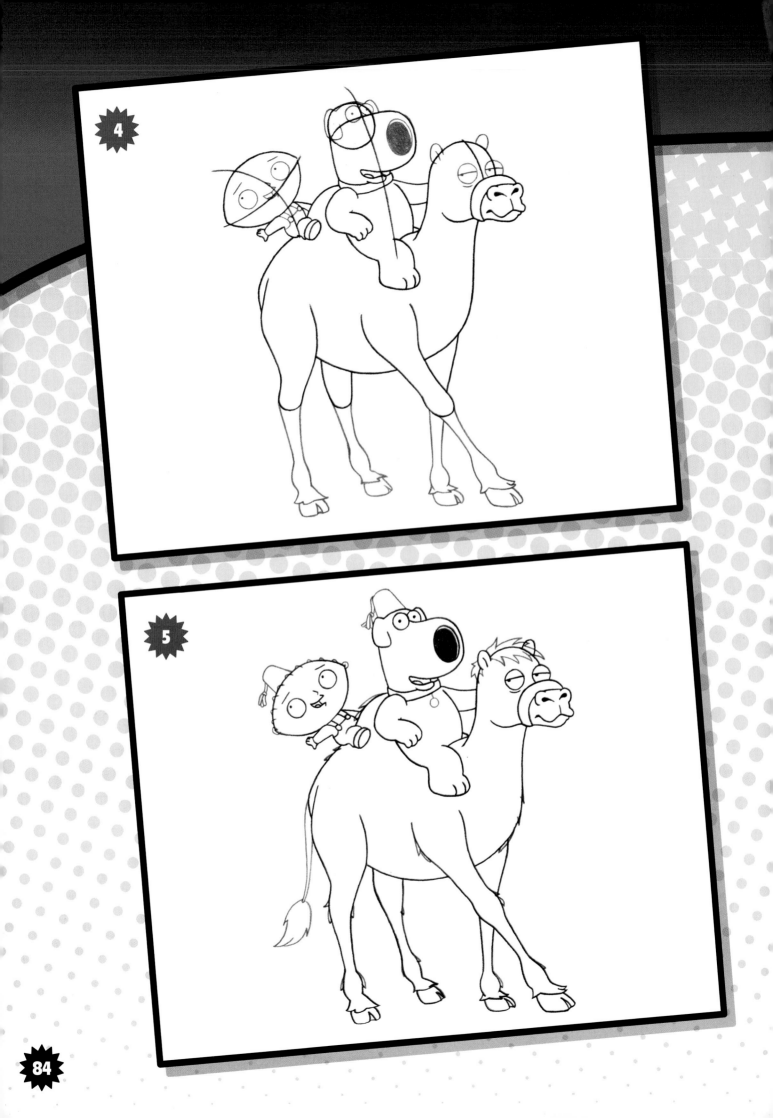

**4**

**5**

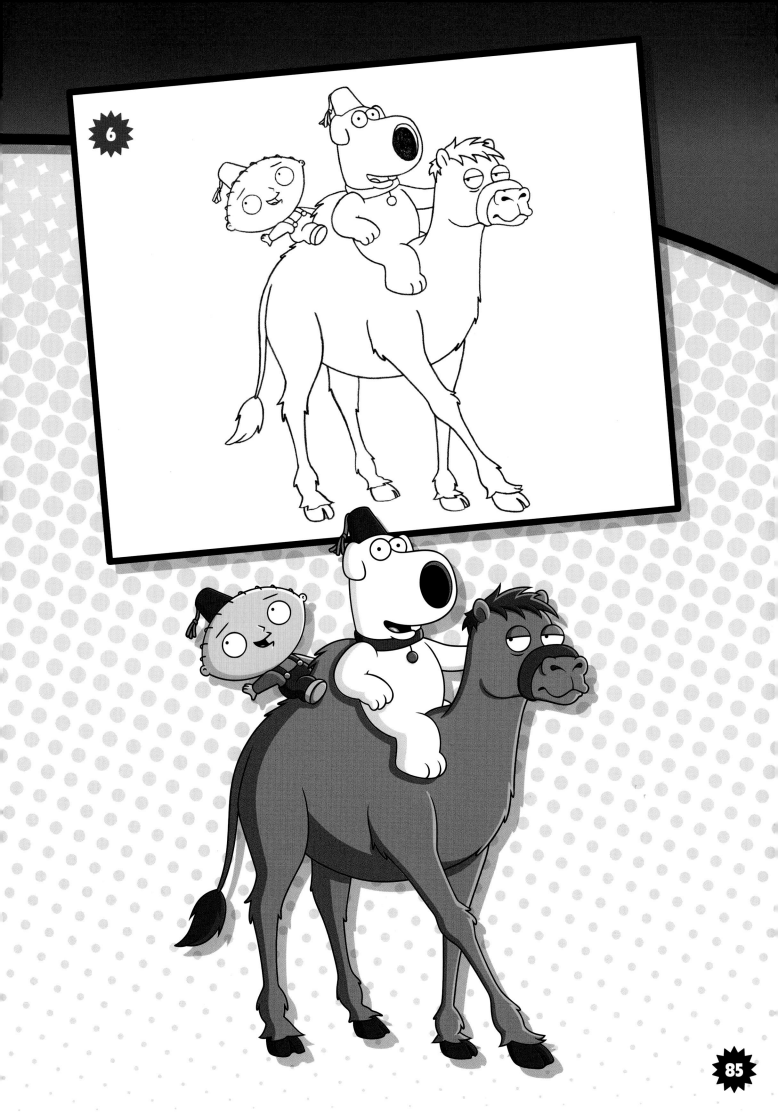

6

# SCOTLAND

**1**

**FAMILY GUY FACTOID NO 17:** IN THE EPISODE "WASTED TALENT," WE LEARN THAT PETER CAN PLAY THE PIANO—BUT ONLY WHEN HE'S DRUNK.

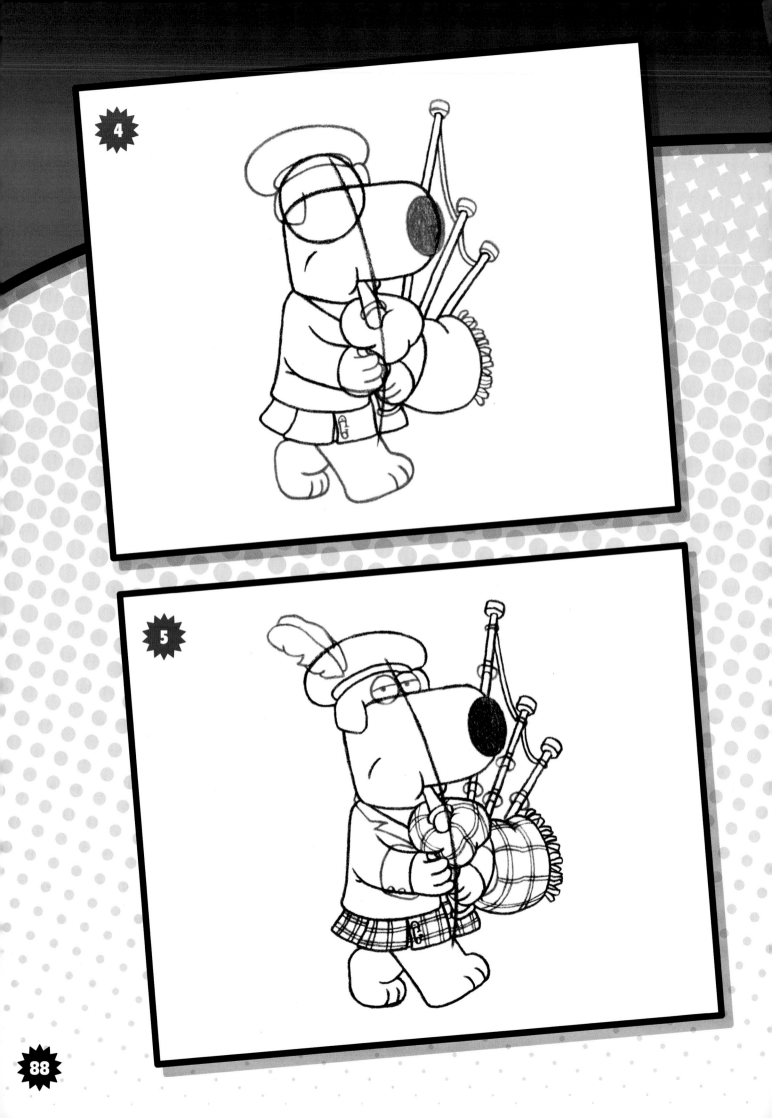

4

5

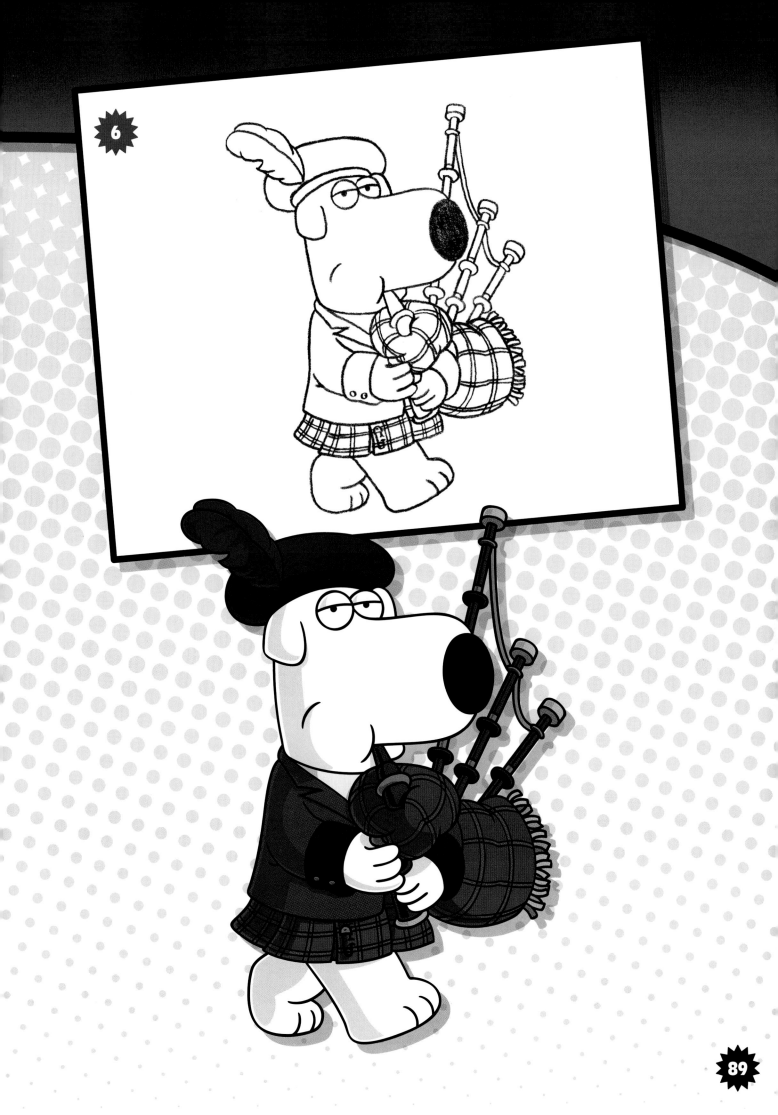

# FRANCE

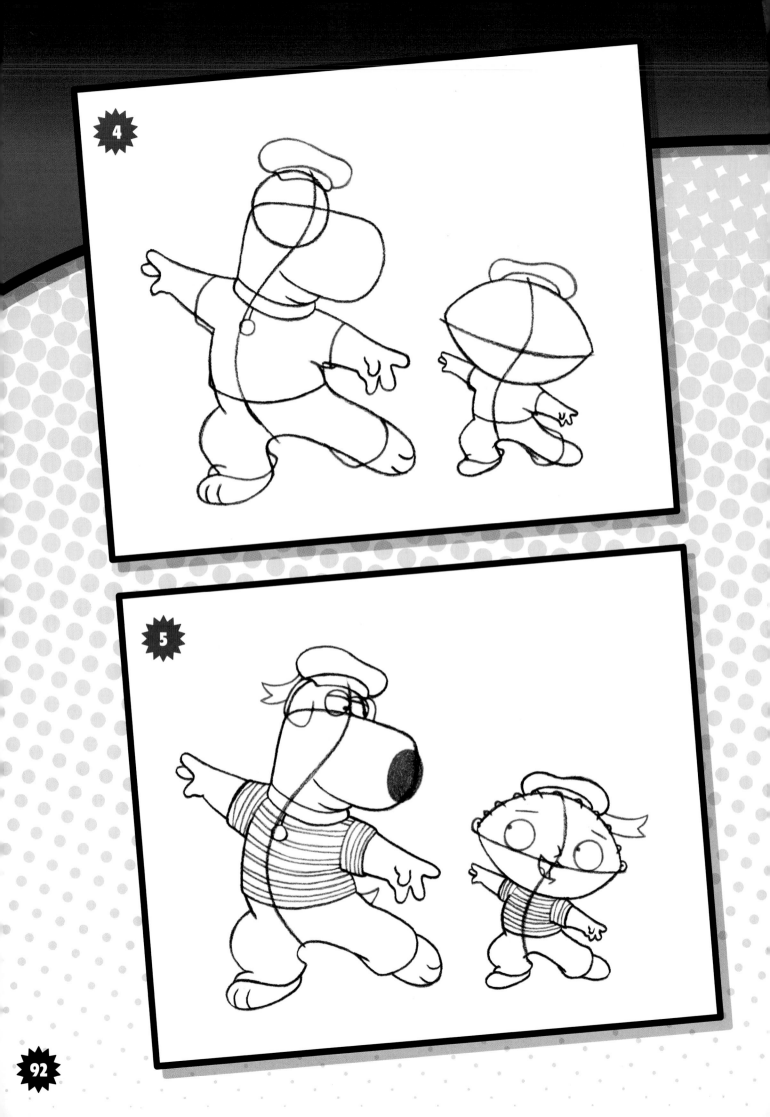

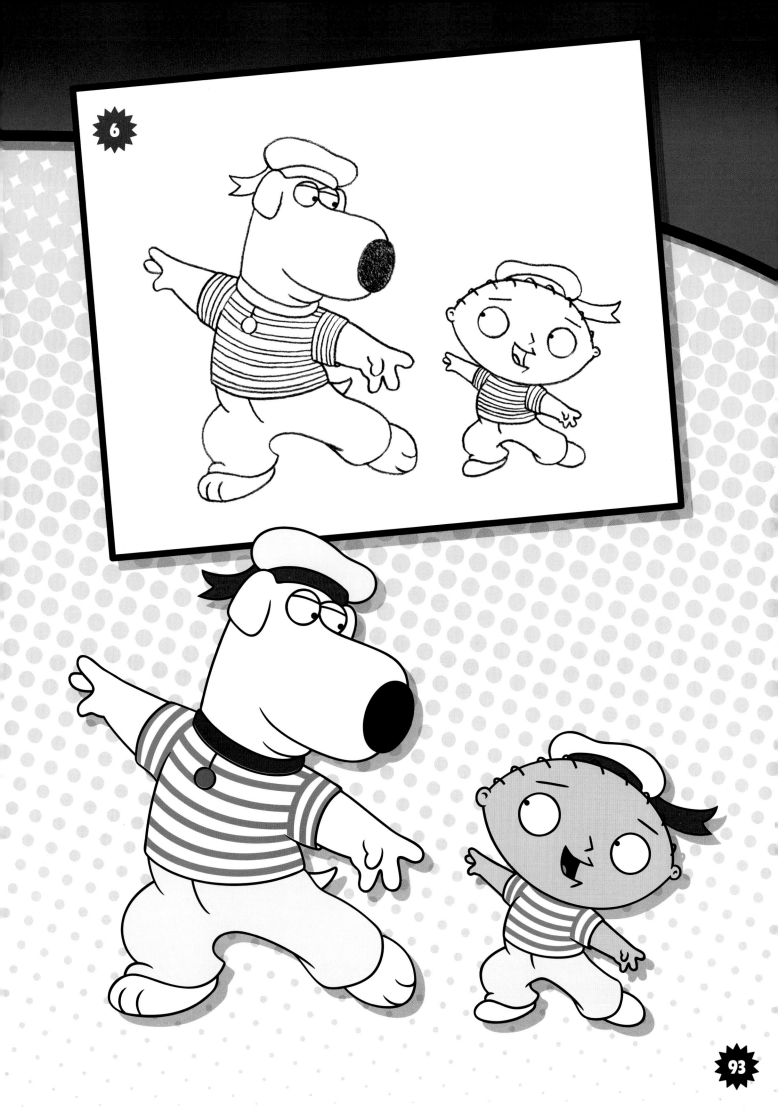

# HITCHHIKING

**❶**

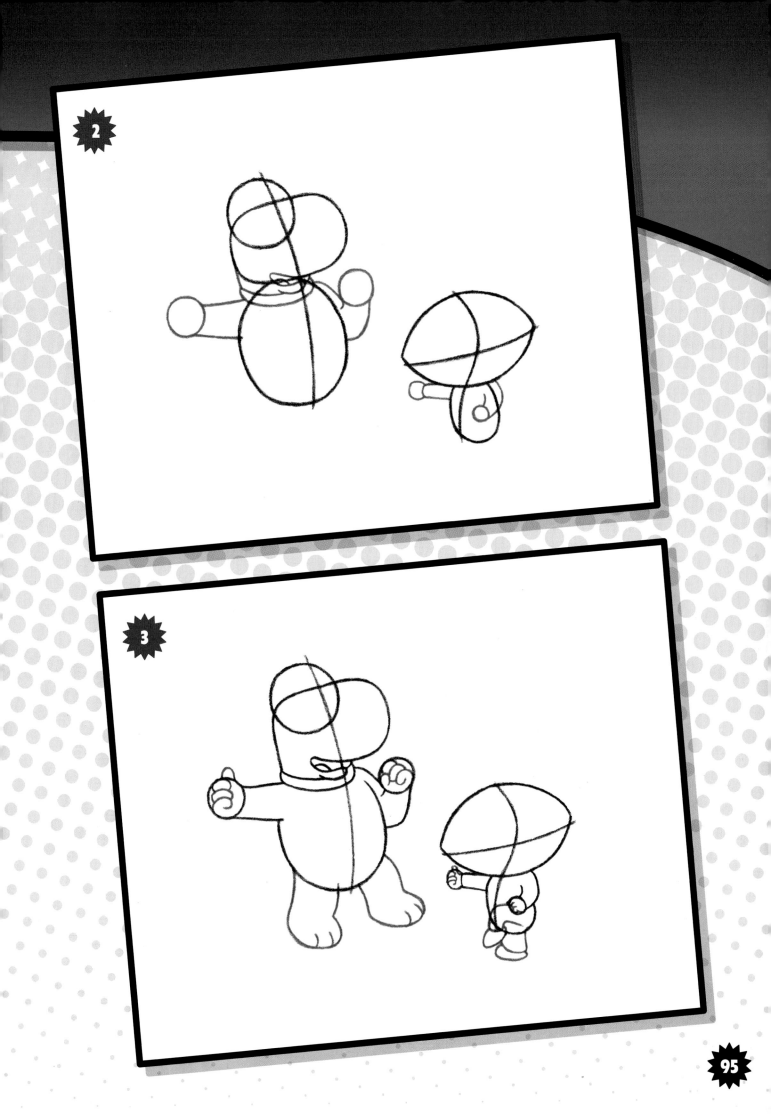

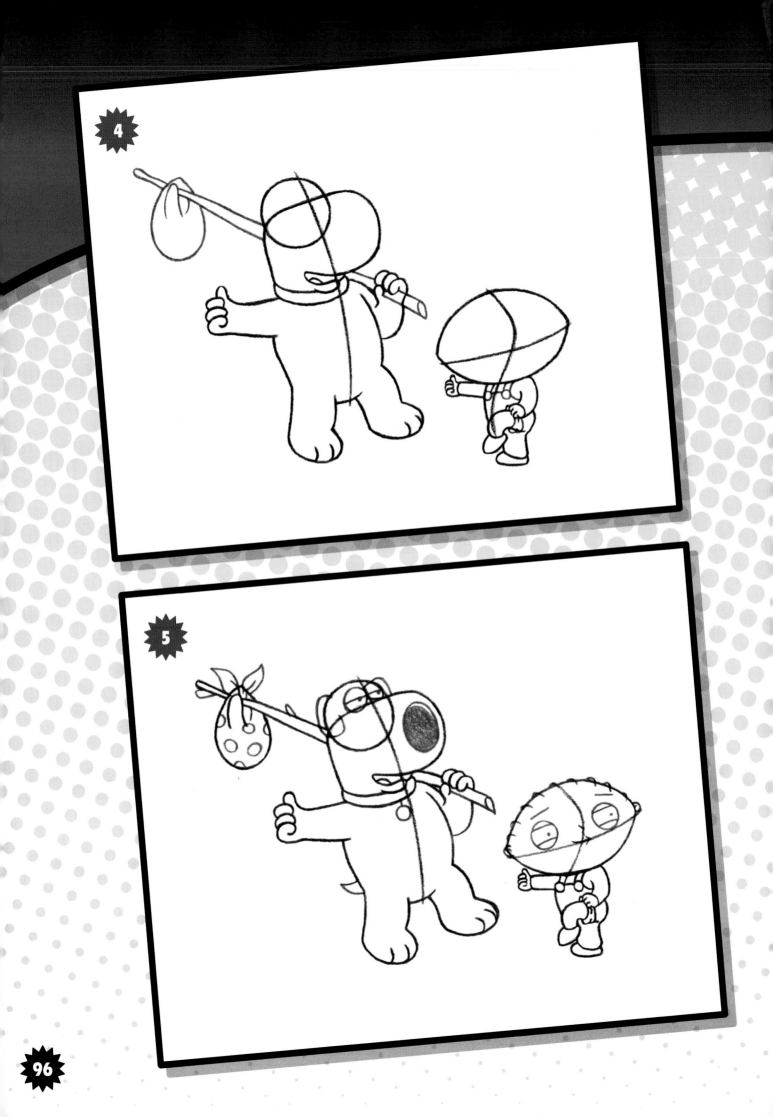

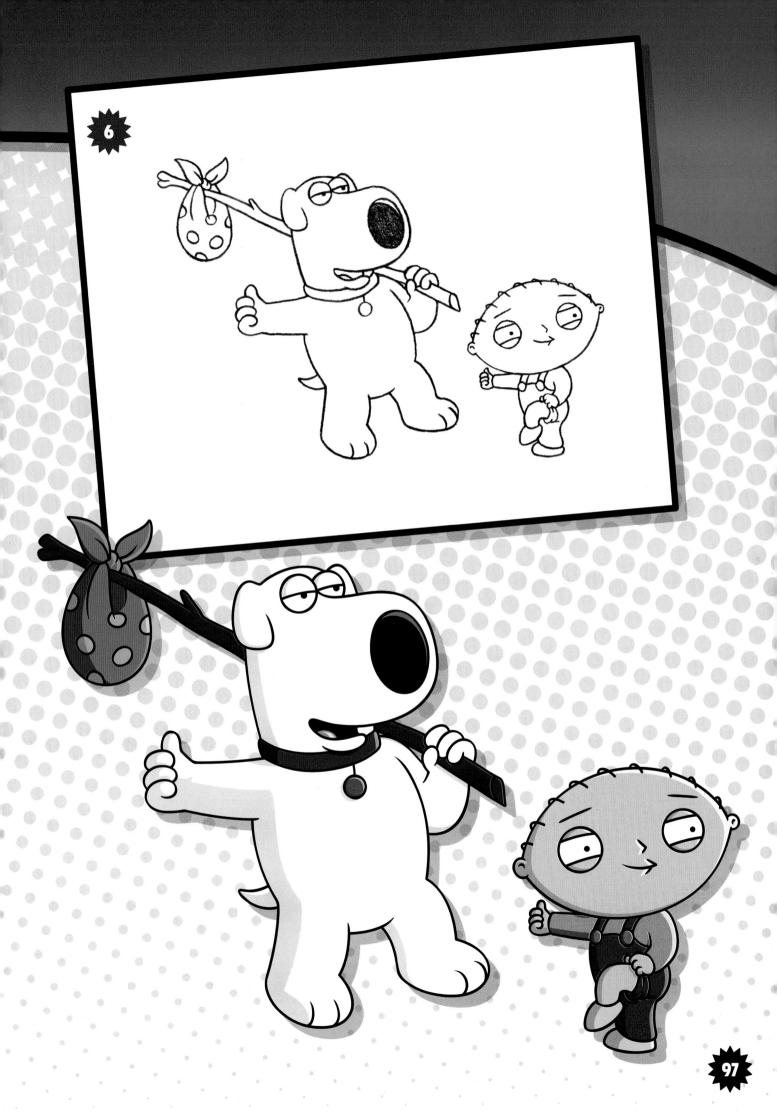

# FAMOUS FEUDS

**FAMILY GUY IS FULL OF INFAMOUS FEUDS:** THERE ARE CONFLICTS INVOLVING ANIMAL NEMESES, SUCH AS THE PERPETUAL FISTFIGHTS BETWEEN PETER AND THE GIANT CHICKEN, CHRIS'S VERY ONE-SIDED, SILENT BATTLES WITH THE EVIL MONKEY, AND STEWIE'S RESENTFUL MASSACRE OF NEW BRIAN AS WELL AS HIS SHORT-LIVED, ANTAGONISTIC RELATIONSHIP WITH HIS PET TURTLE, SHELDON. THERE ARE EVEN SOME RATHER UNBELIEVABLE FEUDS, SUCH AS PETER'S NUMEROUS INSTANCES SKIRTING DEATH AND STEWIE'S BATTLE WITH HIS UNBORN TWIN, BERTRAM. THE FIGHT CONTINUES IN THIS SECTION AS WE REVISIT CHARACTERS FROM A FEW OF THE GRIFFINS' MOST FREQUENT SCUFFLES AND STRUGGLES.

QUAHOG POLICE DEPT. 0485218

QUAHOG POLICE DEPT. 0485219

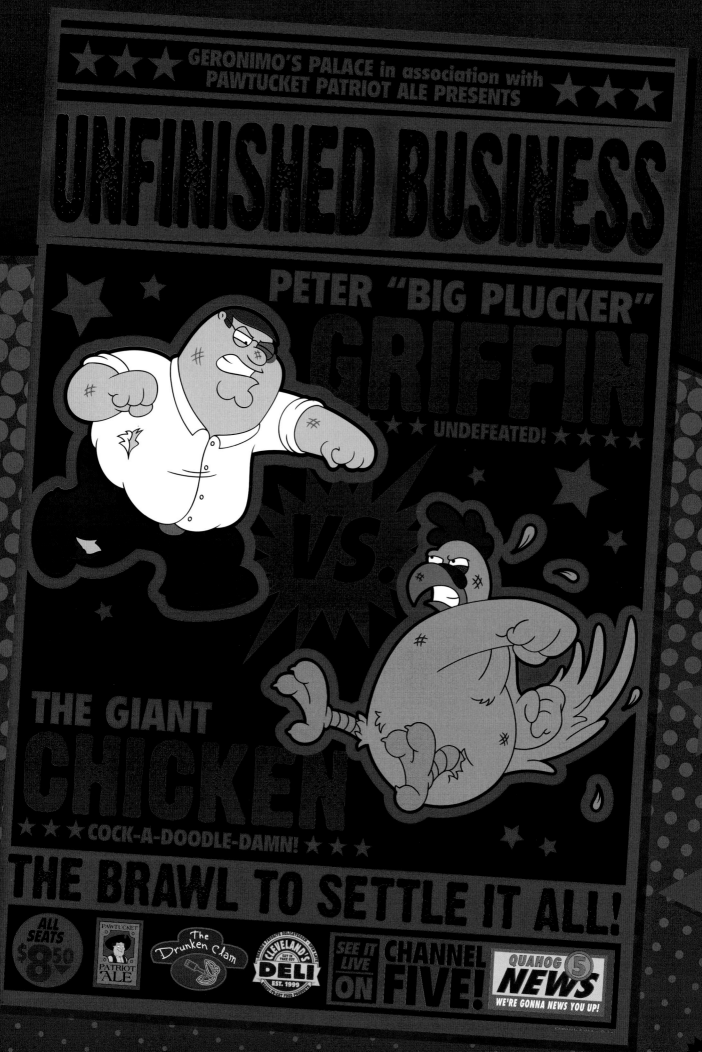

# PETER VS. THE GIANT CHICKEN

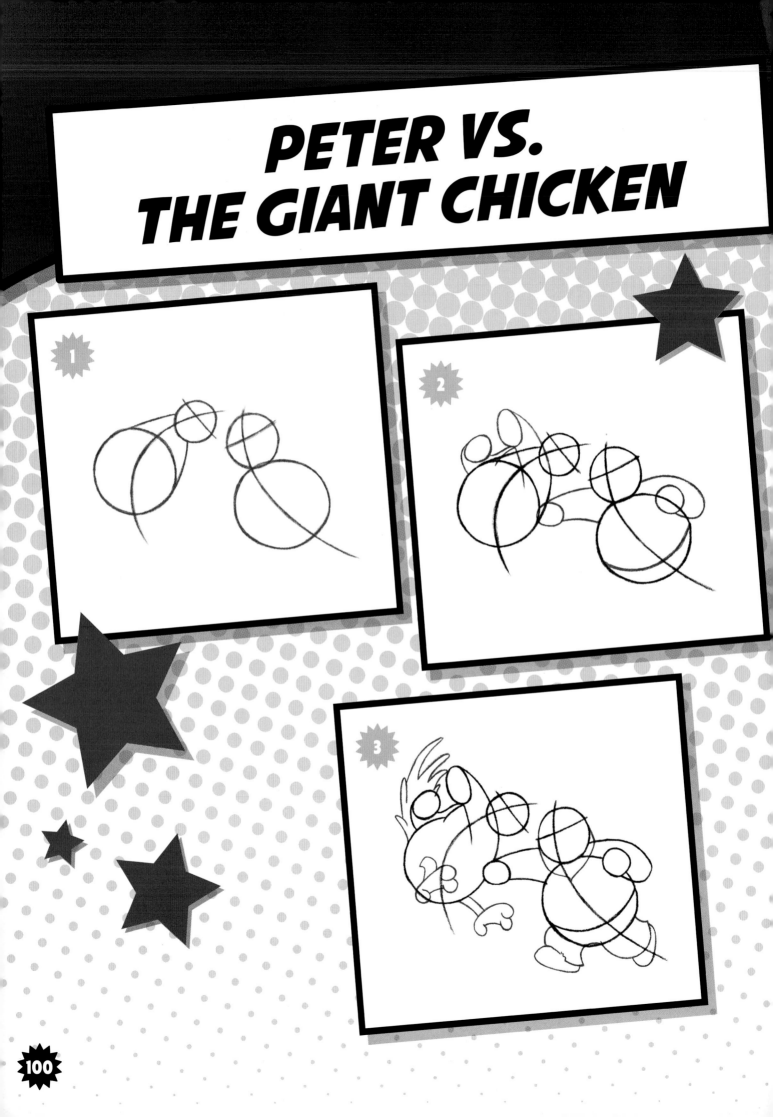

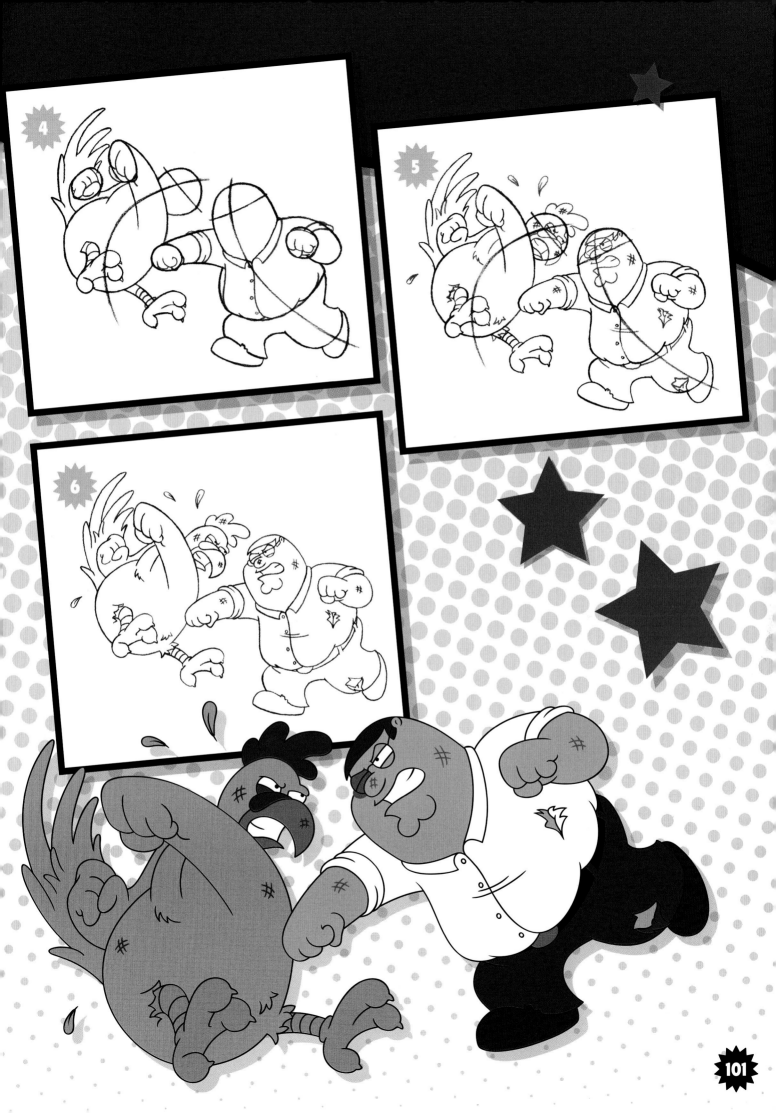

# PETER VS. DEATH

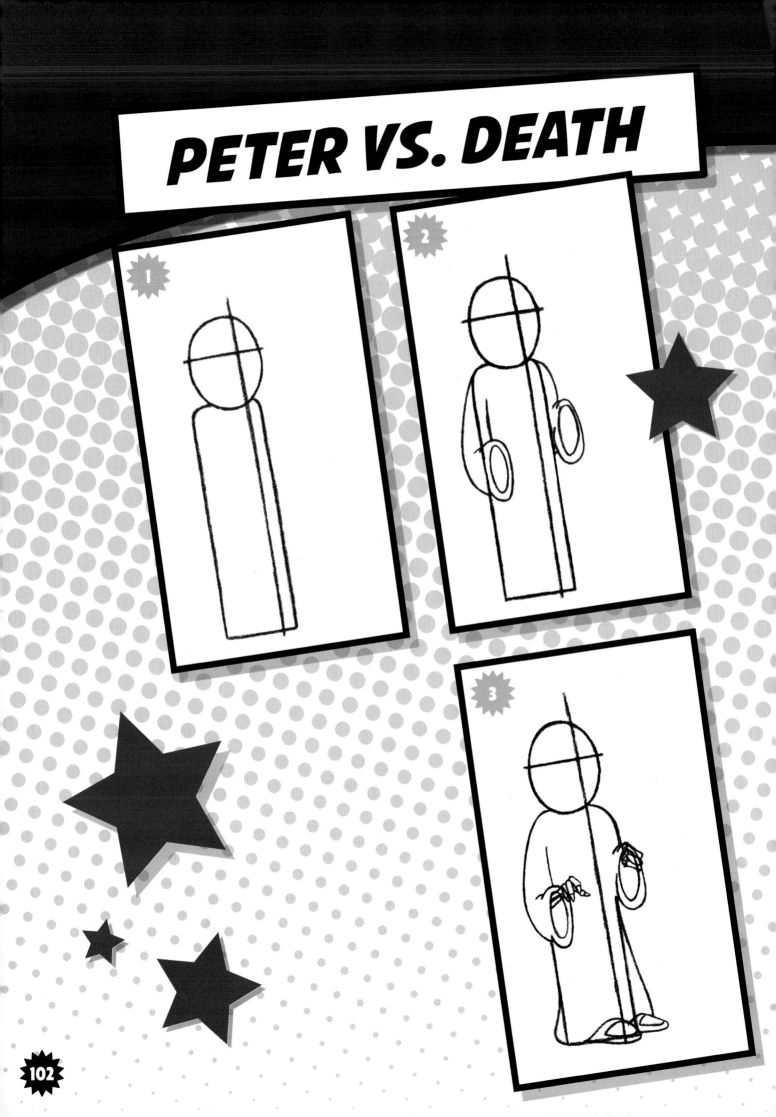

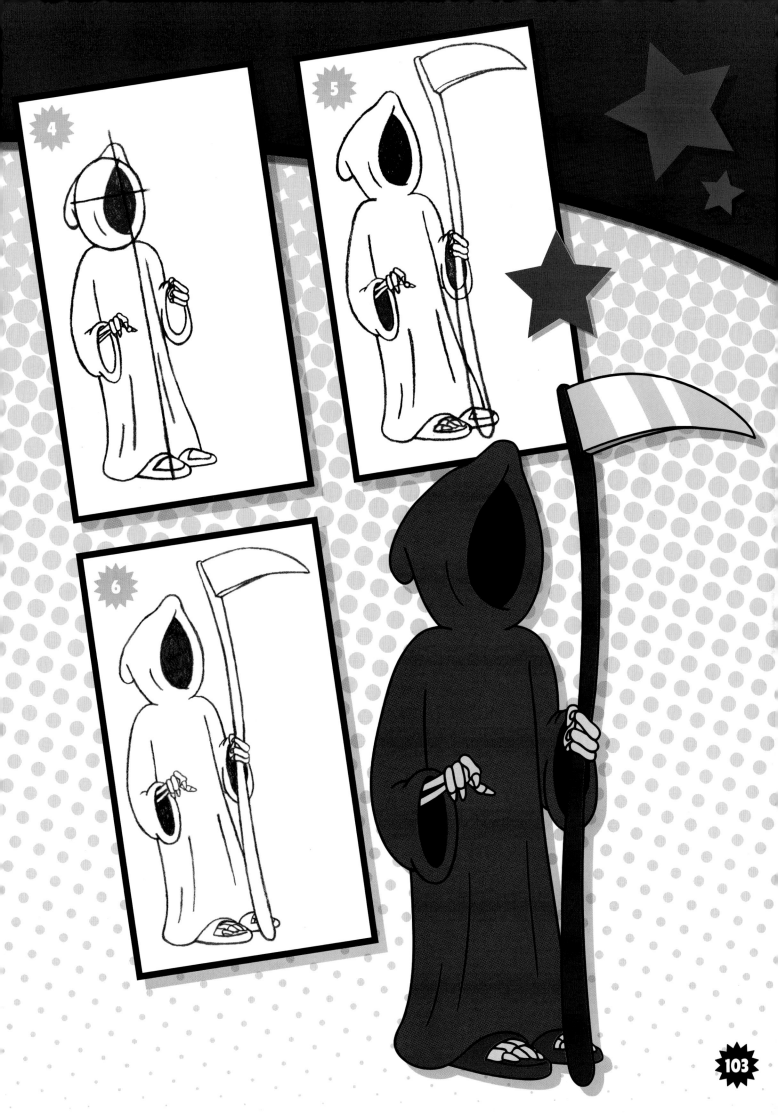

# STEWIE VS. BERTRAM

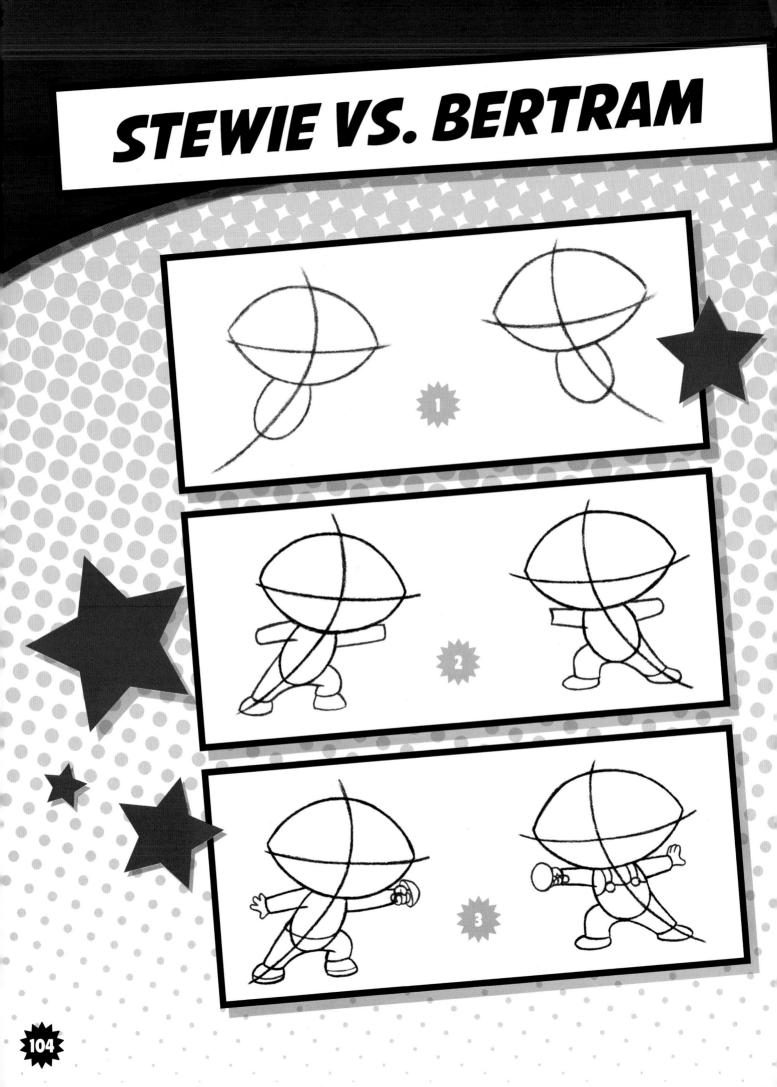

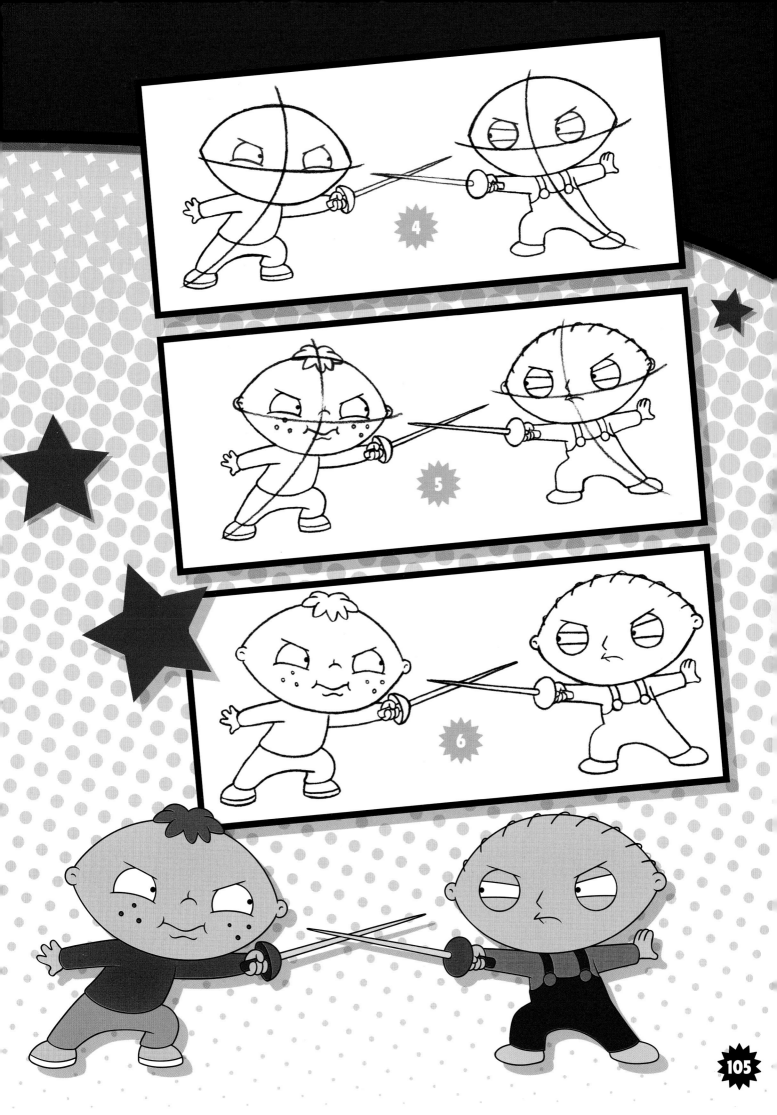

105

# CHRIS VS. THE EVIL MONKEY

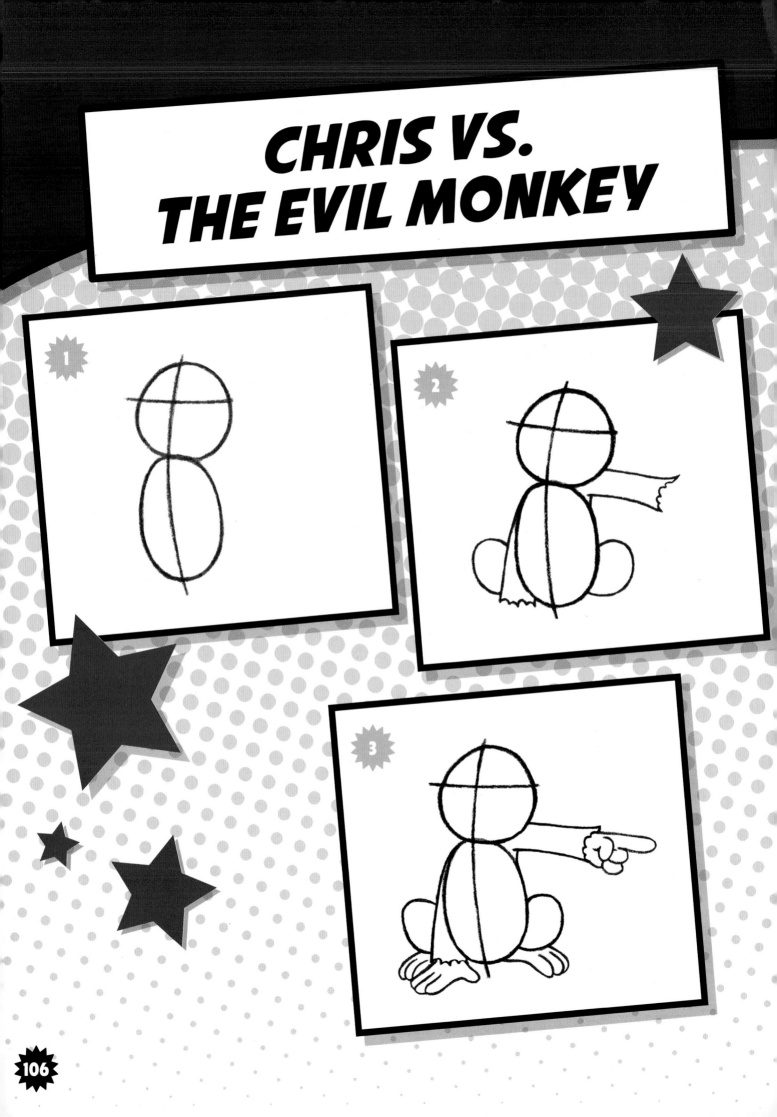

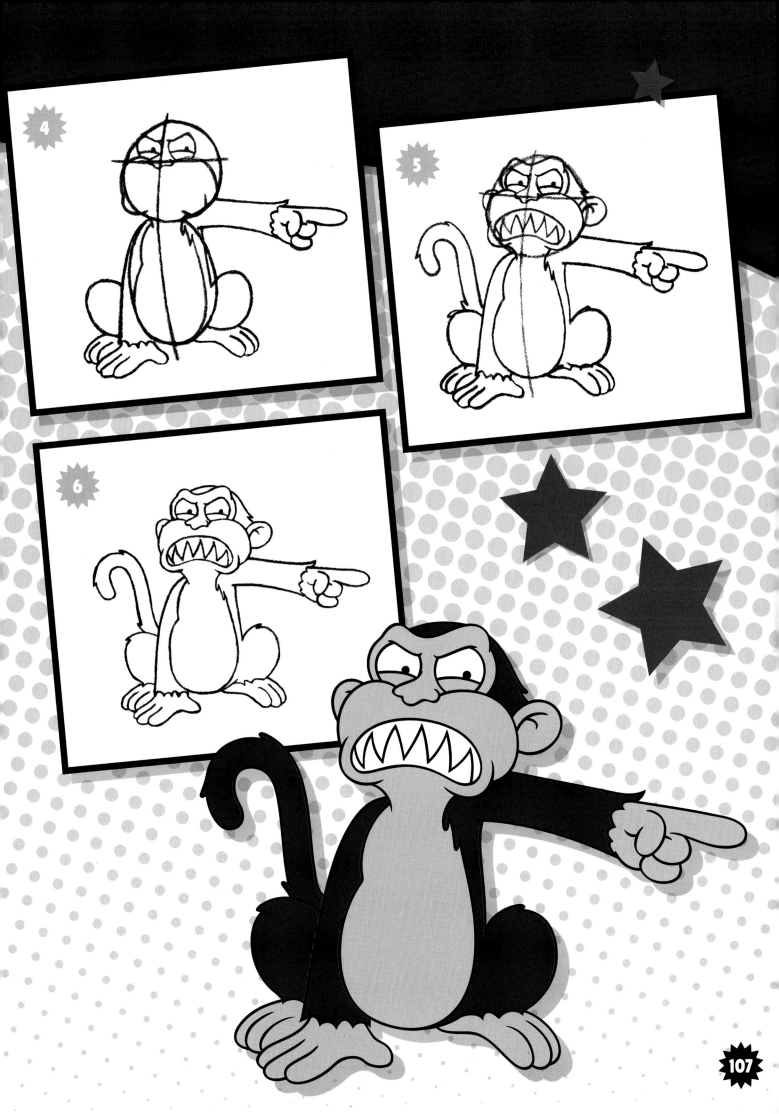

# LIVE FROM LAS VEGAS

That's How I ROLL

LAS VEGAS VISITS AND EXCURSIONS HAVE PROVEN TO BE A POPULAR THEME FOR THE GRIFFINS, WITH THREE SEPARATE VISITS OCCURING IN SEASON 3 AND SEASON 11. "TURBAN COWBOY" REVEALS PETER'S SOLO VEGAS EXPERIENCE, WHERE HE SKYDIVES AND FORGETS TO PULL HIS PARACHUTE, LANDING HIM ON TOP OF THE EIFFEL TOWER AT THE PARIS HOTEL. BRIAN AND STEWIE EMBARK ON A FREE TRIP TO LAS VEGAS LATER IN THE SEASON TO SEE CELINE DION, AND THEY HAVE THE BRILLIANT IDEA OF USING STEWIE'S NEWLY BUILT TELEPORTATION DEVICE TO SHAVE OFF SOME TRAVEL TIME. HOWEVER, "TELEPORTATION" UNFORTUNATELY TURNS INTO "DUPLICATION," AND DOUBLES OF THE DOG AND BABY ARRIVE IN VEGAS FIRST, CREATING SOME PRETTY TERRIBLE ODDS FOR THE ORIGINAL BRIAN AND STEWIE. JOIN THE GRIFFINS FOR SOME VEGAS-STYLE FUN, AS THEY GAMBLE, WINE AND DINE, AND TRY THEIR LUCK IN SIN CITY.

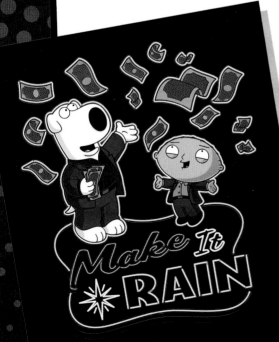

Make It RAIN

# BRIAN & STEWIE

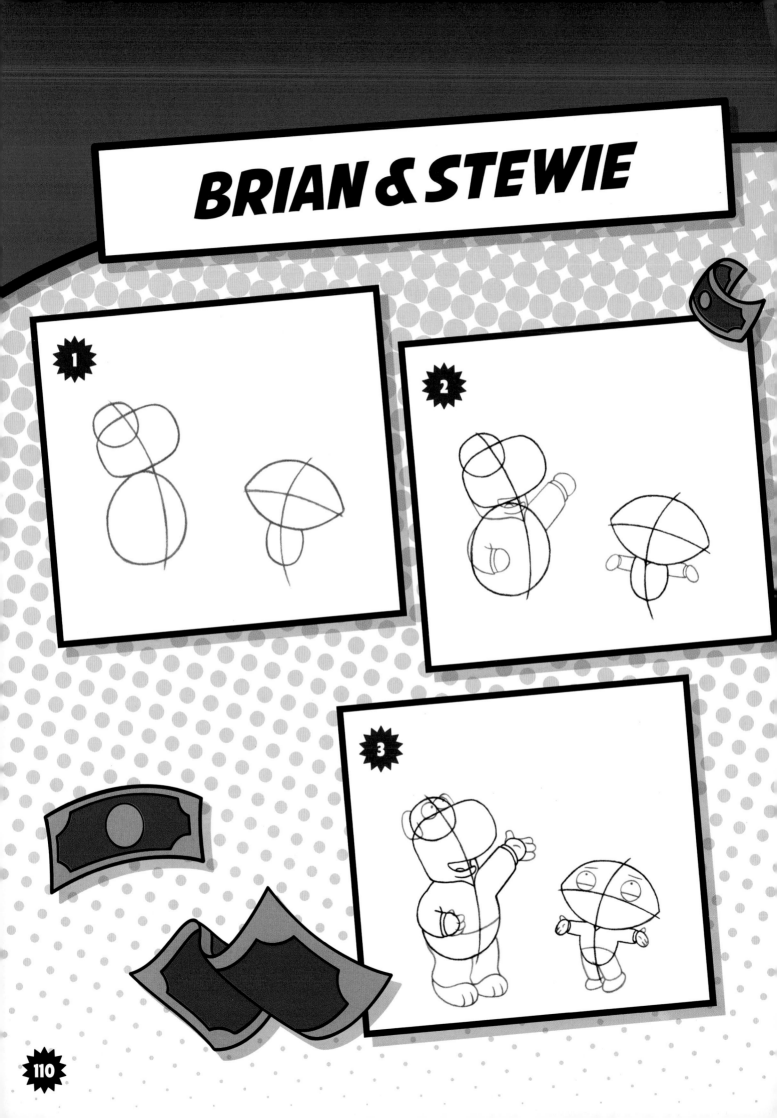

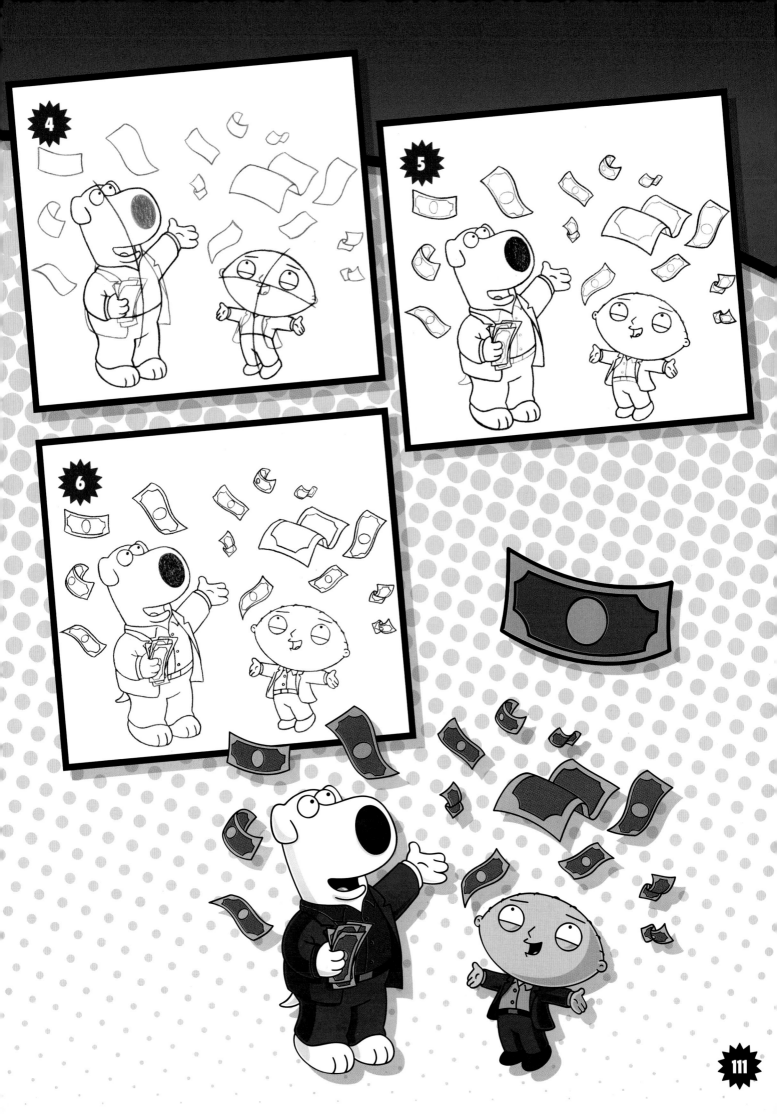

# PETER

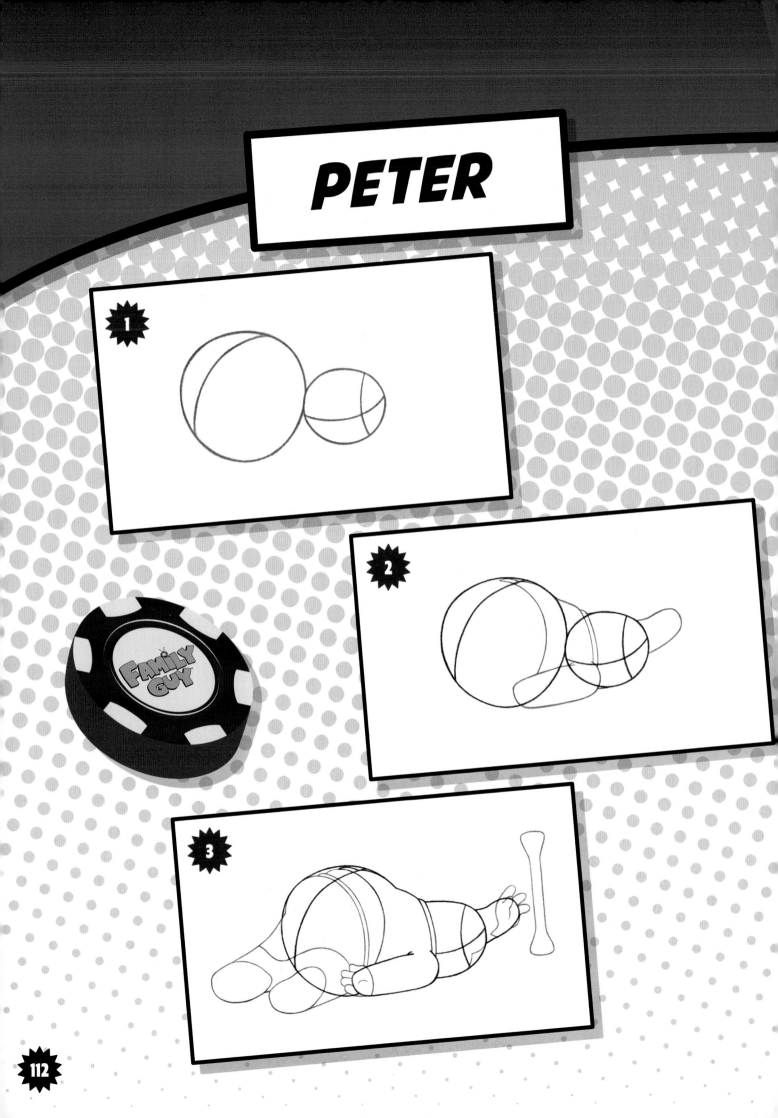

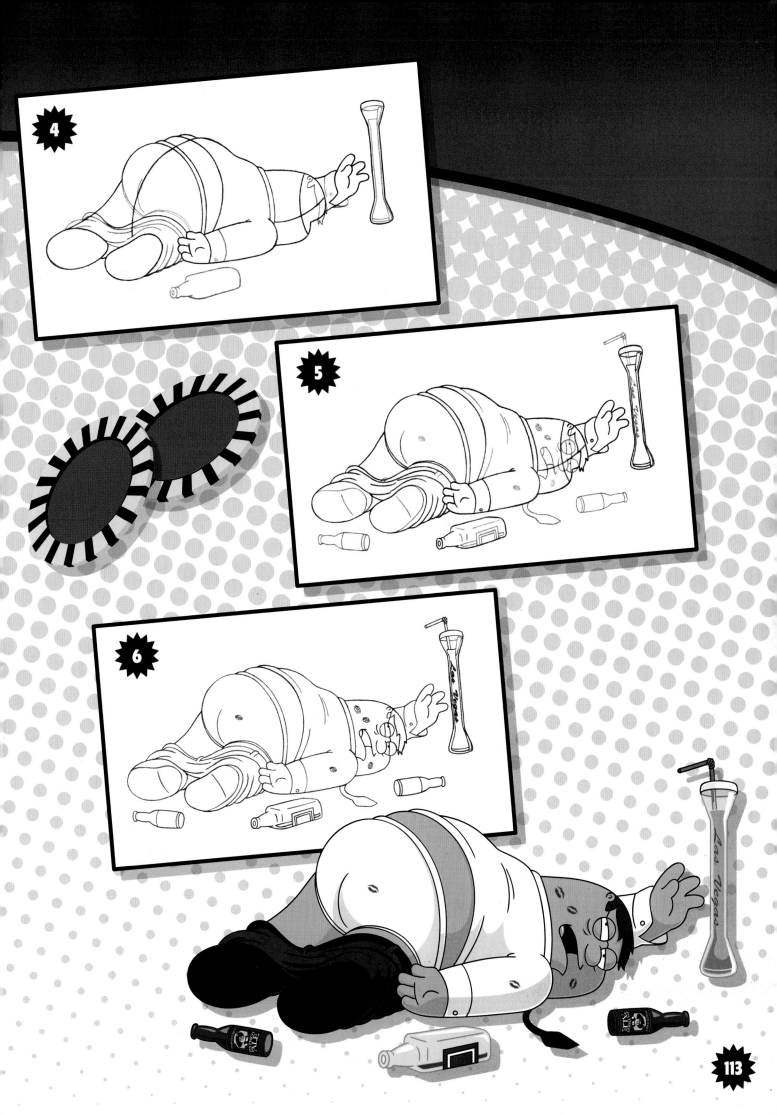

# QUAGMIRE

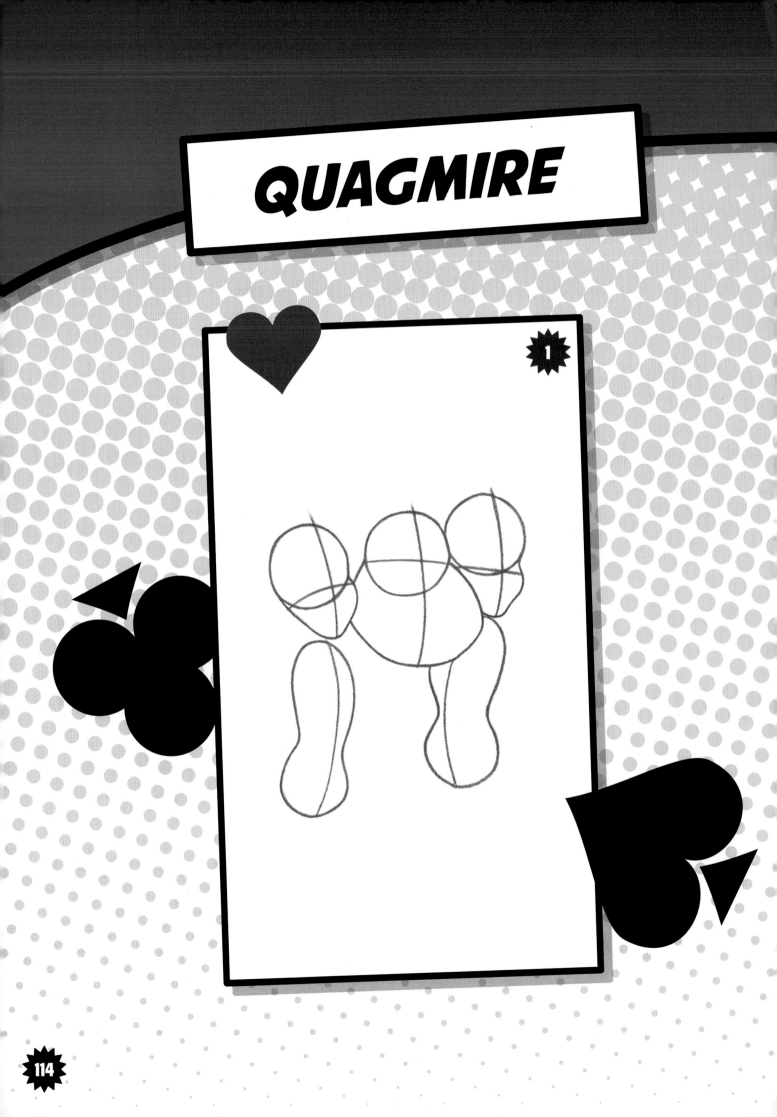

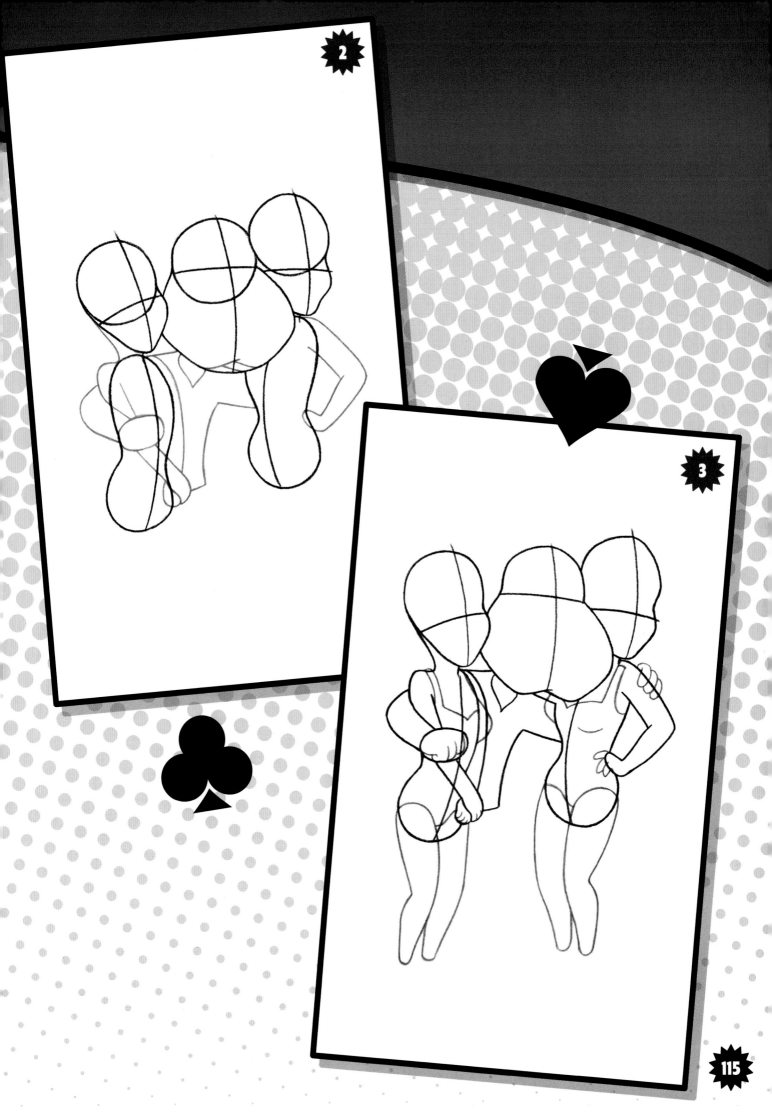

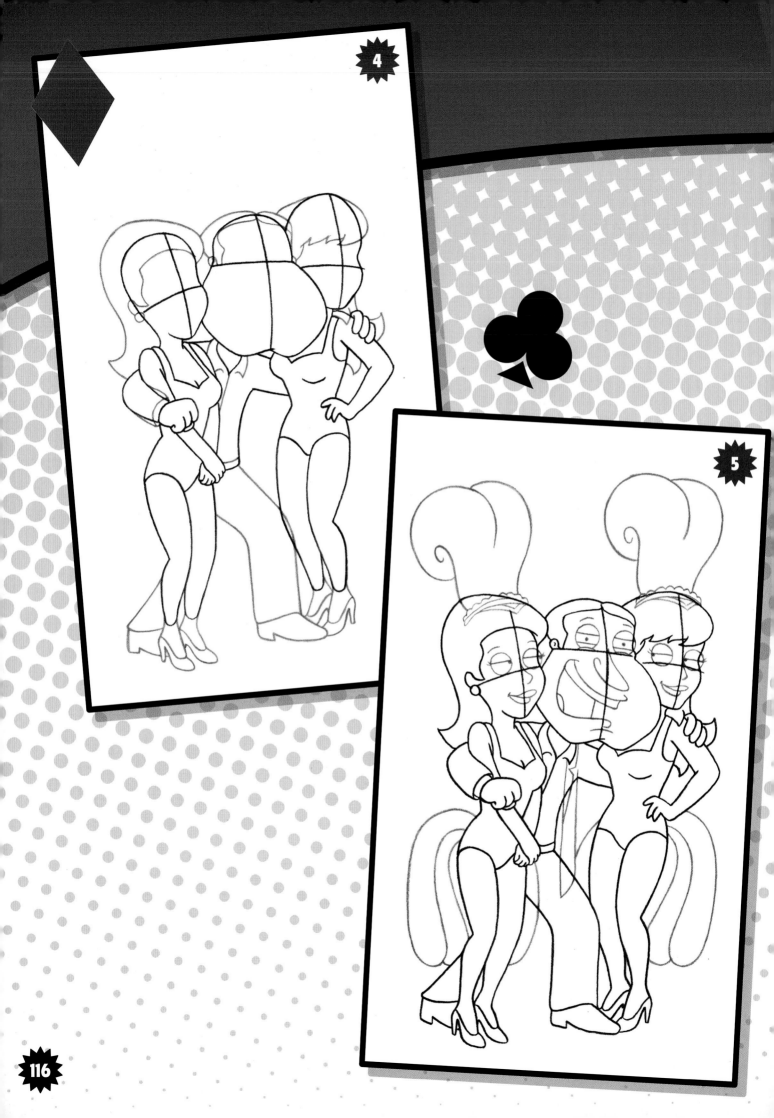

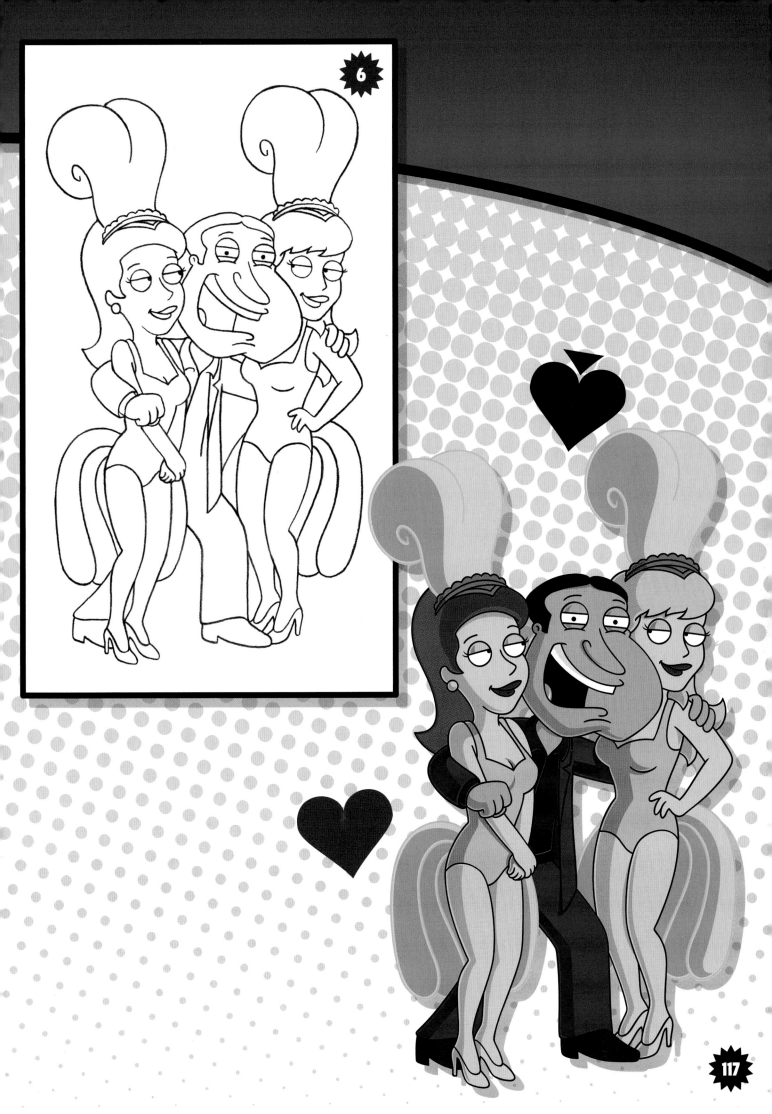

**1**

$$$

**FAMILY GUY FACTOID NO 20:**

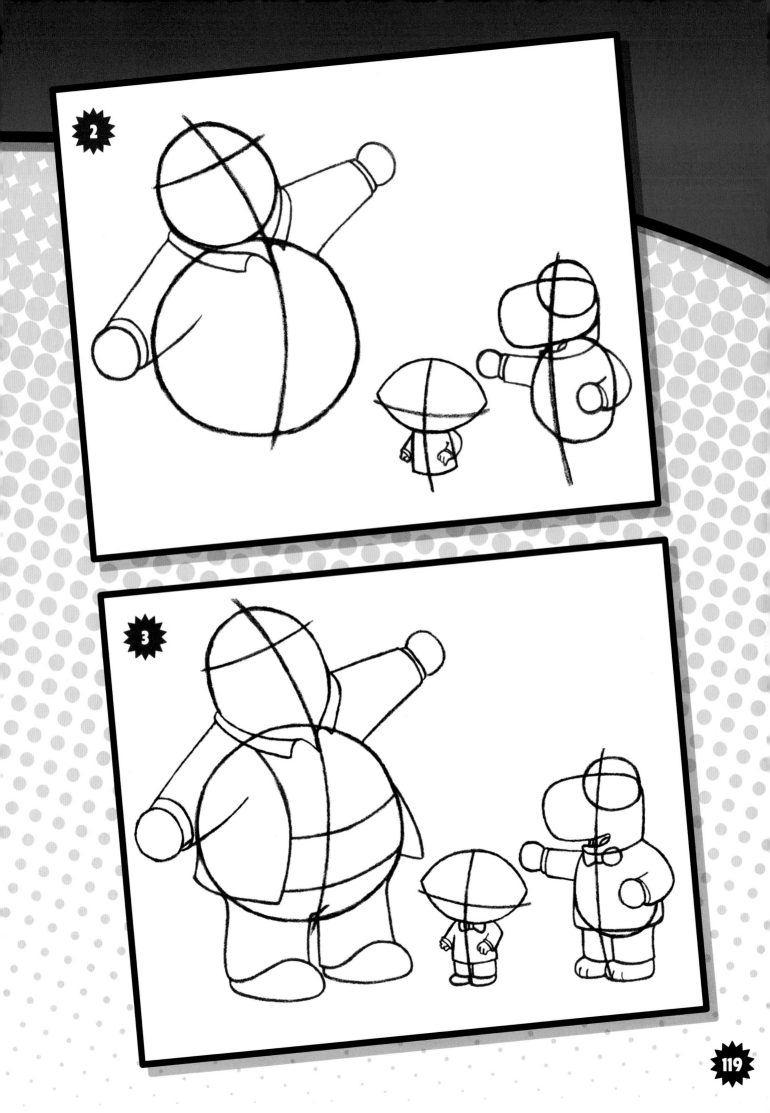

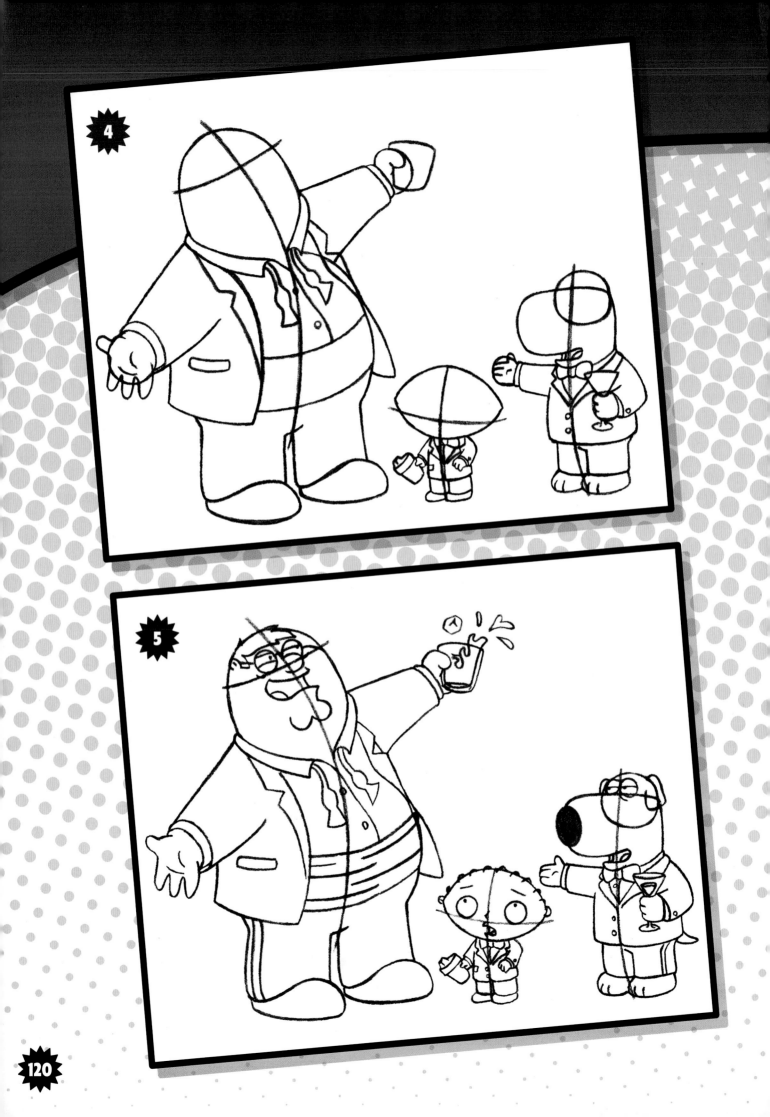

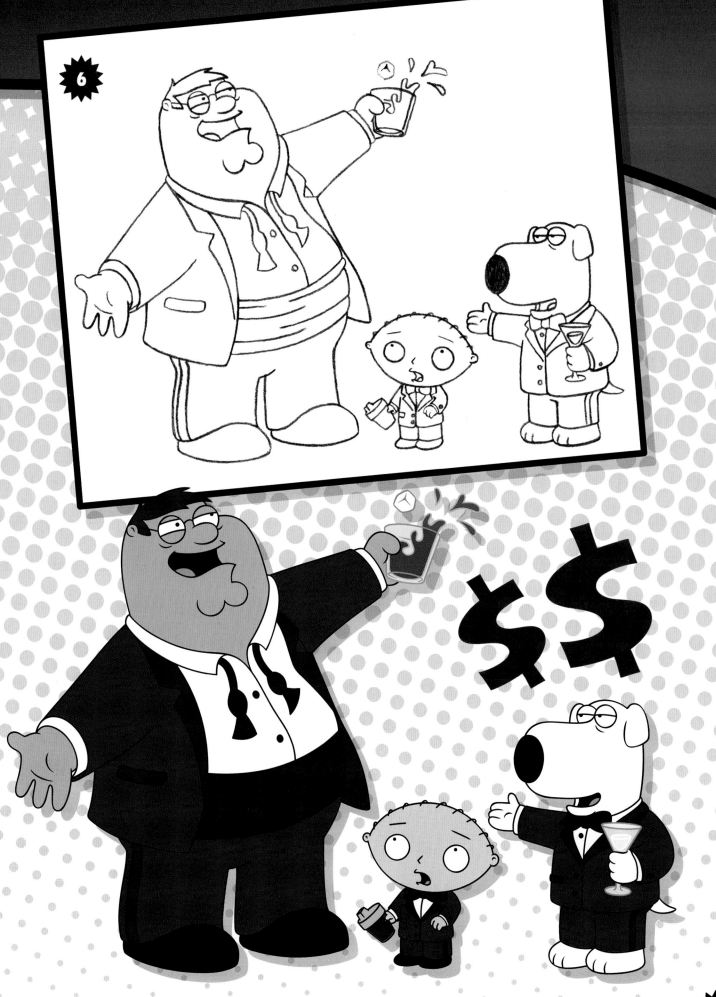

# THE GIANT CHICKEN

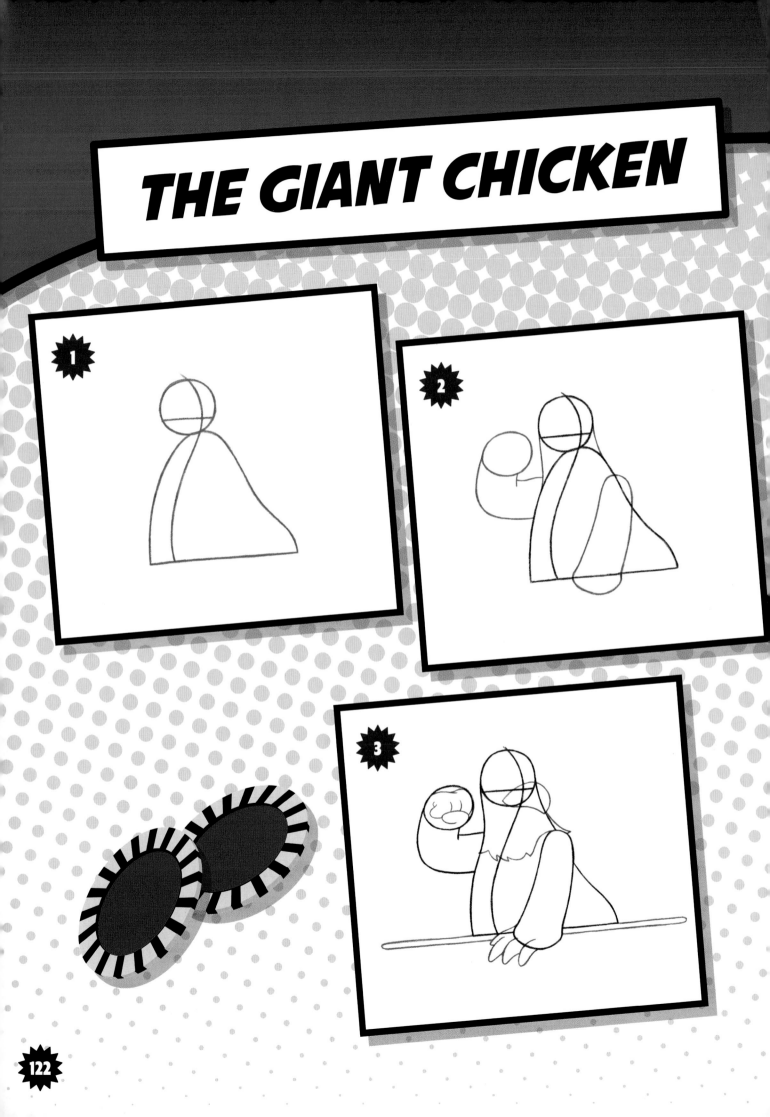

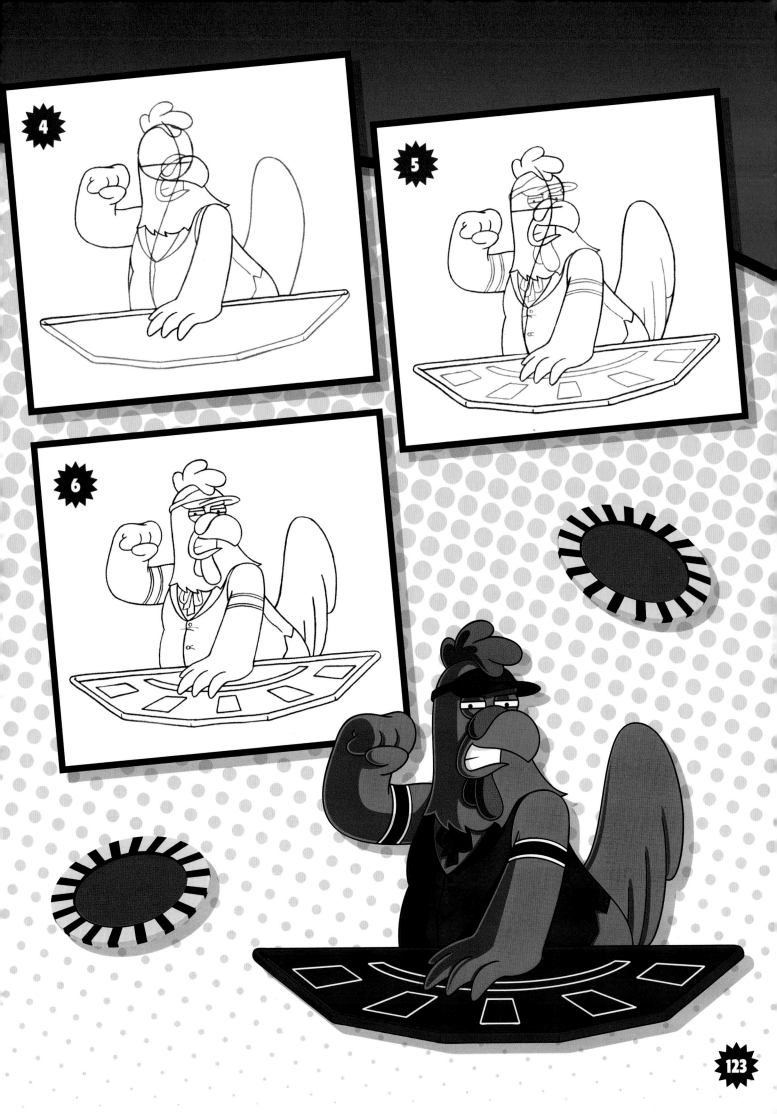

# STEWIE

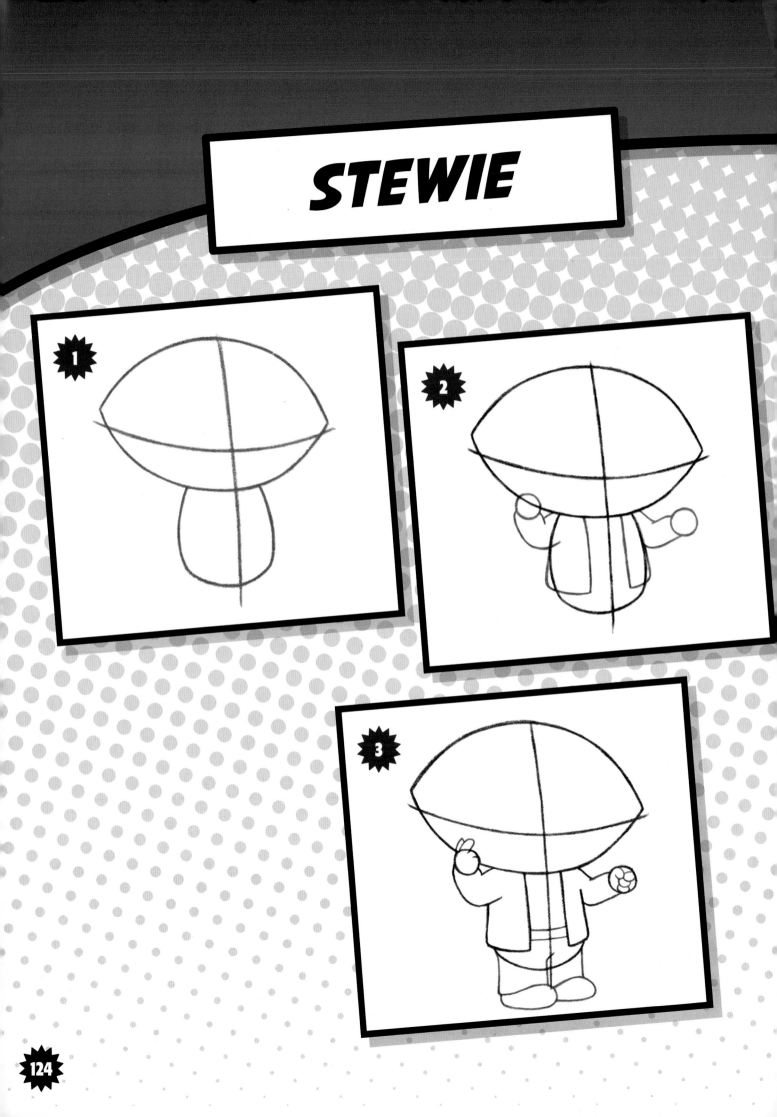

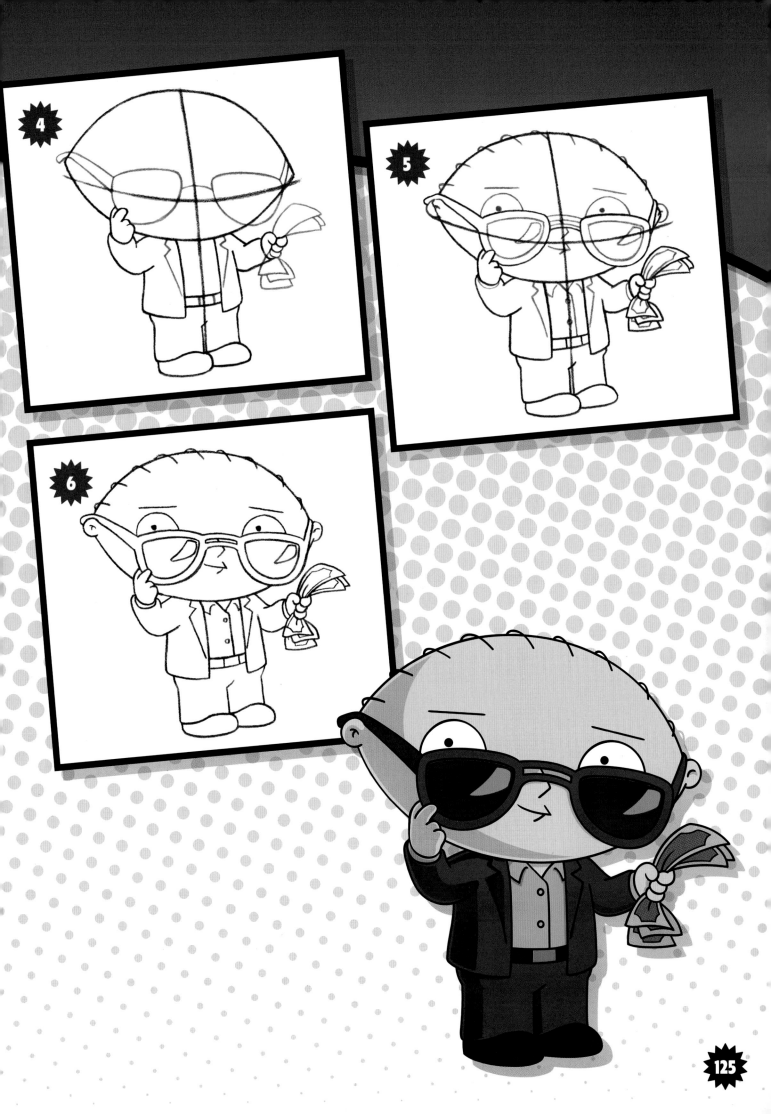

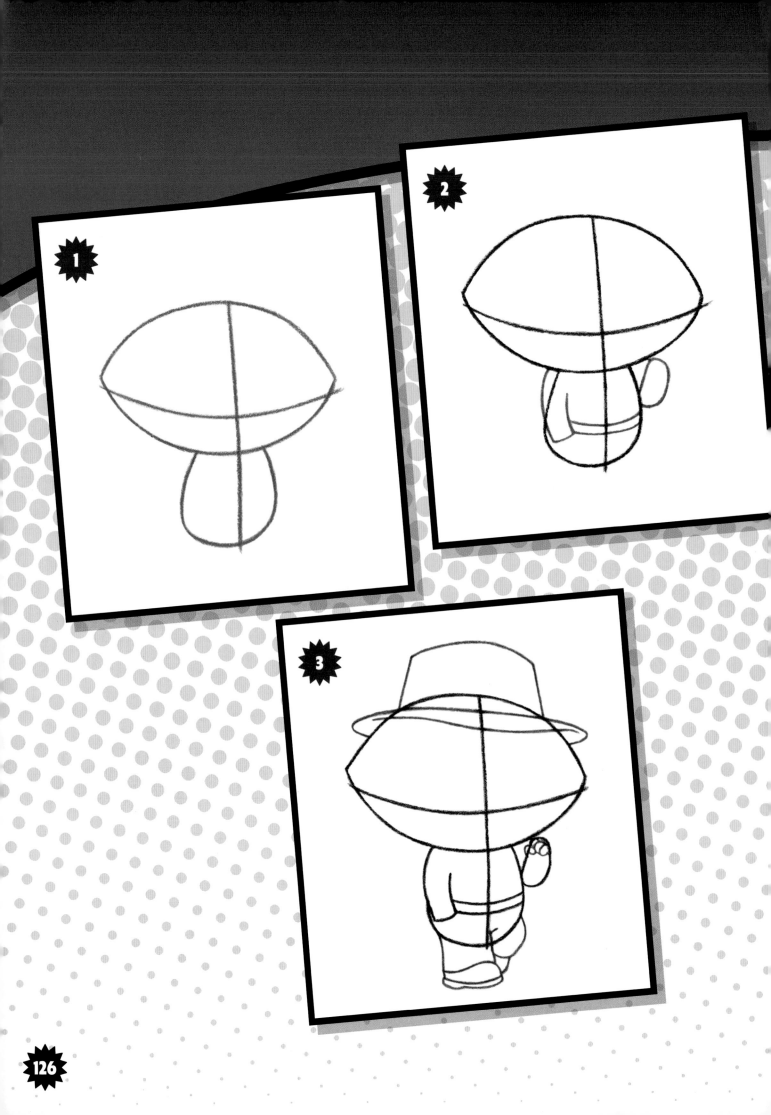

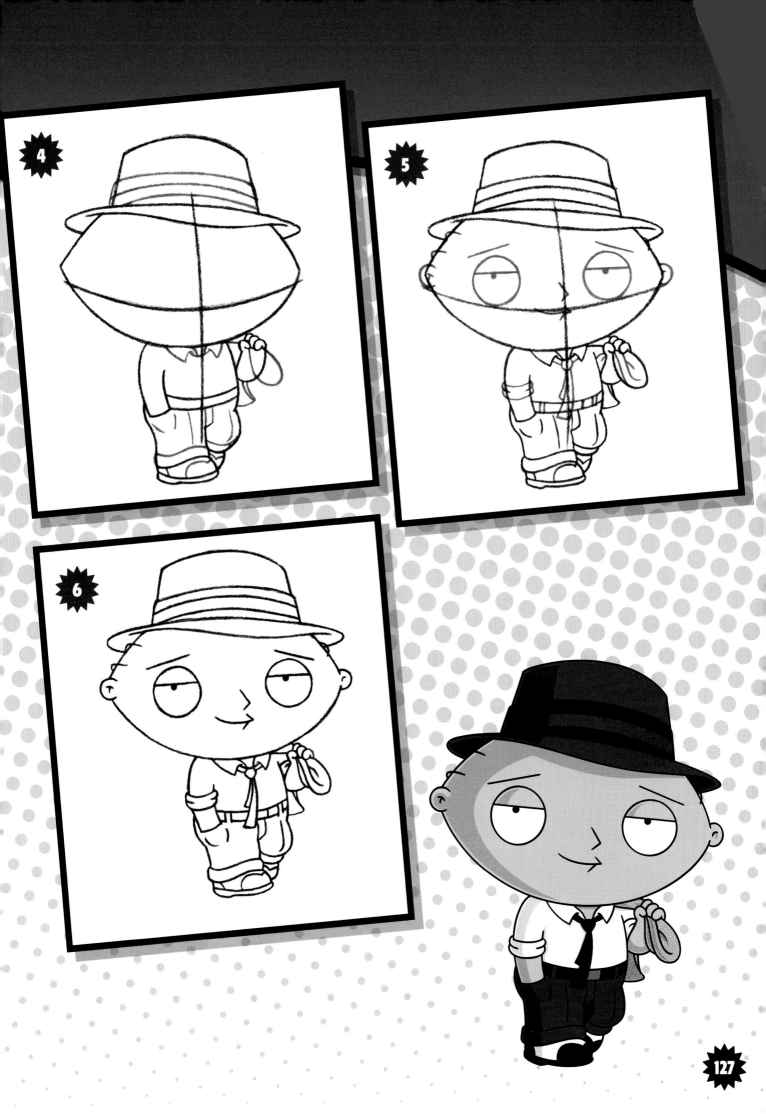

## MOSTLY A'S: YOU ARE BRIAN!

YOU'RE A DRINKER AND A THINKER. PRETENTIOUS? NO, JUST WAY MORE DEEP THAN EVERYBODY ELSE. YOU HAVE A TASTE FOR THE FINER THINGS IN LIFE, BUT ASK YOURSELF THIS—ARE YOU BEING TRUE TO YOU?

## MOSTLY B'S: YOU ARE STEWIE!

A PRODIGAL TALENT AND THE KING OF CUTTING REMARKS—YOU SEEM TO BE SOMEWHAT CONFUSED ABOUT WHO YOU ARE, AND THIS CAN RESULT IN SOME UNJUSTIFIABLY AGGRESSIVE BEHAVIOR. REMEMBER: YOU'RE STILL YOUNG. LIFE GETS EASIER.

## MOSTLY C'S: YOU ARE PETER!

POSSESSING THE WIDE-EYED WONDER OF A CHILD, YOU LOVE ADVENTURES, PRANKS, AND JOKES. SMART YOU AREN'T, BUT YOU HAVE A VERY BIG HEART, WHICH GETS YOU OUT OF A LOT OF TROUBLE. DON'T TAKE THIS FOR GRANTED.

## MOSTLY D'S: YOU ARE MEG!

IN A FAMILY OF "PERSONALITIES," YOU'RE THE "NORMAL" ONE. YOU JUST WANT TO BE LIKED... IS THAT TOO MUCH TO ASK? IT'S NO WONDER YOU'RE NEEDY AND WHINEY, BUT MAYBE TONE IT DOWN A BIT.

## MOSTLY E'S: YOU ARE LOIS!

YOU ARE ONE TOUGH COOKIE, WITH A DEVIANT STREAK. YOU LOVE YOUR FAMILY AND WOULD DO ANYTHING TO PROTECT THEM— DON'T MESS WITH YOU! WATCH OUT, THOUGH, THAT YOUR FAMILY DOESN'T TAKE ADVANTAGE.

## MOSTLY F'S: YOU ARE CHRIS!

AWKWARD IS YOUR MIDDLE NAME (EVEN IF YOUR BIRTH CERTIFICATE HAS YOU DOWN AS "CROSS.") SOME PEOPLE WRITE YOU OFF AS AN IDIOT, BUT YOU HAVE (VERY WELL) HIDDEN DEPTHS...